WITHDRAWAL

A DICTIONARY OF
VENETIAN PAINTERS

A Dictionary of

VENETIAN

PAINTERS

Volume 3. 17th Century

by

PIETRO ZAMPETTI
Director of Fine Arts, Venice

F. LEWIS, PUBLISHERS, LIMITED

Publishers by appointment to the late Queen Mary

LEIGH-ON-SEA

PRINTED AND MADE IN ENGLAND

©

Copyright by

F. LEWIS, PUBLISHERS, LTD

The Tithe House, 1461 London Road

Leigh-on-Sea

SBN 85317 181 5

First Published 1971

Published by F. Lewis, Publishers, Ltd, The Tithe House, 1461 London Road,
Leigh-on-Sea, England, and Printed at The Blackfriars Press, Leicester

VENETIAN PAINTING IN THE SEVENTEENTH CENTURY

THE Exhibition held at Ca' Pesaro in 1959 attracted the interest of scholars to a fairly un-
familiar period in the long history of Venetian painting. Unfamiliar, one must explain,
because little appreciated or valued. Indeed, as all attention was generally centred on the far
more splendid sixteenth and eighteenth centuries, the seventeenth century in Venice was usually
considered to be a time of weariness and decadence. However, from 1959 onwards there has been
a reawakening of interest in this century, and a campaign to rescue from obscurity the events and
the achievements of a period which, even though it could boast no Caravaggio, Velasquez,
Rembrandt or Rubens, yet played a lively part through a wide variety of artists in the problems
and the movements of seventeenth century art.

It has already been stated, at the end of the Introduction to the previous volume, that at the
beginning of the century, Venetian painting seems to be passing through a phase of weariness,
owing to a widespread academistic reliance on the works of the great painters of the Cinquecento.
There are outstanding personalities, however, such as Palma il Giovane, bound to tradition in his
own way, or Seraceni, who goes to Rome and flourishes on his Caravaggesque experiences. In
the first decades of the century, one must not overlook the presence in Venice of artists from
outside. The most important of these are Domenico Fetti from Rome, Bernardo Strozzi from
Genoa and finally Jan Liss from Oldenburg. Three painters very typical of their age, though
entirely different from one another. Fetti had a melancholy nature and seems to be wrapped in
nostalgic memories of lost myths, which are recreated by his imagination, like visions of a lost
world. His painting, which lacks any classical compositional balance, attains such lightness of
touch, especially in themes so rarified as the myths of the Kunsthistorisches Museum in Vienna,
that form appears to melt in the atmosphere till it seems no more than vibrant patches of colour
shimmering in the diffused light. Hence it would not be out of place to say that he has managed
to avoid the heavy, dramatic baroque of that time in favour of certain types of pictorial expression
which were to be taken over at the beginning of the next century by the tenuous, etherial trends
of European rococo. Liss is entirely different, even though the two painters have some points in
common: he is exuberant and full of vitality. The bulkiness of Rubens (whom he certainly knew)
melts away in his thrilling painting, which sometimes reaches unparalleled peaks of excitement,
as in *St. Jerome inspired by the Angel* in the Tolentini Church, Venice. After passing through a
naturalistic period of his own choosing, during which he found inspiration in the lively stimuli of
everyday life, the painting of Liss becomes enhanced by a tonal lightness leading to open radiance
—a foretaste of the state of Venetian painting a century later.

Strozzi, the last of these three "great ones" who came to Venice in 1630, can certainly not be
considered to stand in the same position as the other two. A great deal has been written about him
as a painter who still has some affinity with Mannerism. He came from Genoa, where he was
subjected to Tuscan, Lombard and Flemish influences. After his arrival in Venice, the oily
sluggishness in his pictures gives way to a greater play of light and a lighter, more delicate touch.
The *St. Sebastian* in the Church of San Benedetto, with its bright colours, is an obvious tribute to
the tradition of Venetian painting in the previous century. It is impossible to say whether it was
the stimulus of impressions received from contemporary artists (particularly Rubens) which
brought him to such a pitch of eloquence and confidence, or whether it was rather his own
instinctive and consistent development. At any rate, his position is quite different from that of

Palma il Giovane; he does not merely carry on the tradition of the Venetian sixteenth century but, rather, comes alongside and rediscovers it, adapting it then to the requirements of his own personality.

It would certainly be arbitrary and not entirely true to state categorically that these three painters were responsible for the renewal of Venetian art in the seventeenth century. However, the extent to which their work has filtered through to later artists must be acknowledged. Fetti certainly played an important part in the formative period of Francesco Maffei, as did Strozzi with regard to Forabosco. Mazzoni too can only be fully understood in the light of these predecessors.

An artist with his own special place in the first decades of the century is Alessandro Varotari, known as Padovanino. He was the originator of a predominantly classical movement which lasted throughout the century, sometimes intertwining with other tendencies, but also keeping up certain contacts with the sixteenth century which, in the long run, turned out to be productive. He has affinities not only with the Venetian painting which immediately preceded him but also, completely missing out the whole complex world of Mannerism, models himself on the young Titian and perhaps even on Giorgione, with an obvious tendency towards archaism, that is, a reversion to the original classicism. All the same, he is not a reactionary but rather an isolated intellectual who wished to recall a lost world. His attitude is a conscious one and must be taken very seriously, because it had a multitude of consequences. His pupil Giulio Carpioni carries on this classical trend right in the middle of the century, keeping aloof from the various baroque currents which had already reached the city and province of Venice. Padovanino is also the starting point for a painter who participates fully in the problems of his day, that is Gerolamo Forabosco. He attains a freedom of expression which is sometimes caustic and sharp, sometimes moving. The picture of a *Rescue Scene* in the church of Malamocco near Venice (Lido) is a literal representation of a dramatic event which is felt with the urgency of a story. His watchful, penetrating observation of life, ready to catch every shade of emotion, shows him to be a painter of great potential, an acute interpreter of the human condition.

That is how the two most vital trends of the century—one close to the real world and sanctioned by the great lesson of Caravaggio, the other continuing, with variations, along classical lines—intermingle and develop in Venice, following a changeable course which it is hard to pin down to a precise formula. The name of Carpioni has already come up: his classicism is of a pastoral kind, almost like Poussin in a minor key. His baccanalia and mythological scenes take us into a literary world. His painting is concise, with bold outlines, flooded with sometimes brilliant light, especially after he has left behind certain early tendencies towards "Luminism" (that is, chiaroscuro, with contrasts of light and shade). He is far removed from the dreamy, evanescent classicism of Fetti, but it seems possible that some of his works may have attracted the attention of the young Giambattista Tiepolo, if one calls to mind the *Sacrifice of Polyxena* in the Museum of Chicago. In *Portrait of a Woman* in the Museum of Berlin-Dahlem he also shows the extent of his talents as a portrait painter: in this picture there is a great deal of sincere warmth and humanity. So, in Carpioni we are given further proof of the multiple aspects of seventeenth century art in Venice.

Another outstanding personality is Pietro della Vecchia, an artist who has been known up to now chiefly as a plagiarist of sixteenth century originals and imitations of Giorgione. But today his personality appears to be considerably more complex. It is true that he recreates sixteenth

century themes in baroque terms; his art is full of reminiscences, but also of unexpected flashes of originality. The unrestrained and sometimes unpleasant violence of his colours and his post-Caravaggio Luminism handed down through Saraceni and Le Clerc, are facts which place him in a position of exceptional originality, particularly in view of some of his violently dramatic works. The *Crucifixion* in the Church of S.Lio and *Noah coming out of the Ark* at S.Antonin show how the Luminism of Caravaggio had become well established in the Lagoon, where it had been interpreted in such an inspired and unexpected way, pervaded by a profound anxiety and founded on an obvious reaction against classicism.

Perhaps the best known figure among the large numbers of painters in seventeenth century Venice is Francesco Maffei from Vicenza. At first he was linked to Maganza—not a very significant artist—but succeeded in broadening his scope by studying the works of the great painters of the Cinquecento and later came near to Liss as well. Mannerism led him towards an intense, tormented vision, with exciting colours overemphasised to the point of hyperbole. But in time his colours are softened down, thus refining his painting, which then becomes lofty and aerial. Maffei is a somewhat isolated but extremely gifted artist. In works like the *Procession* in the Duomo Vecchio of Brescia, it is his personal creativity which accounts for the dramatic rendering of the story, the striking characterisation and the eddy of lights which pour into the sky through the torn clouds. In other works, like the *Rest on the Flight into Egypt* (in which traces of Fetti's influence can be discerned), he has created a still, placid harmony of colour. In short, Maffei acquires certain qualities which are proper to Mannerism and subsequently transforms his pictorial language to suit the demands of baroque taste. Thus he accentuates contrasts, creates violent and haunting imagery, and plans his compositions in a dynamic and stimulating way.

Sebastiano Mazzoni, a Florentine by birth, settled in Venice when he was still young and never left it. In recent years critics have shown an interest in his work, which was left in comparative obscurity until a few decades ago. His origins are not yet clearly known, and it is not easy to see what were the influences on his early years. He had a restless character, ready to seek and find inspiration anywhere. In Venice his initial affinities were with Bernardo Strozzi; but he very soon turned aside and set out, assimilating on the way the knowledge he needed, towards an artistic achievement which one need not hesitate to describe as profoundly personal. No other painter of that time (it was mid-century by the time Mazzoni was in full production) was more original and self-sufficient than he was. One can reach a better understanding of his talented, many-sided personality by reading his writings and verses. Besides being a poet and painter, he was also an architect and responsible for the house on the Grand Canal (Palazzo Morolin) commissioned by another artist, Pietro Liberi. The word grotesque has often been applied to the art of Mazzoni. But in reality his nature is highly dramatic and tormented. His art, with its new rhythms and cadences, the generous and bold structures in its composition, shows him to be one of the most genuinely gifted artists working in Venice in the second half of the seventeenth century. His best-known works disclose subtle sensitivity and a vigorous, dramatic imagination. In him, as in Maffei, there are no traces of classicism and in his pictures there is a complete lack of detachment. In *Cleopatra's Feast* (1660) at the Smithsonian Institute, Washington, he seems to herald certain feathery, limpid styles which in time became common in Venetian painting. In other pictures like the *Death of Cleopatra* (Rovigo, Accademia dei Concordi) he achieves intense drama, full of the tragedy of death.

In the second half of the century, alongside Mazzoni who lives and works in solitary dignity,

artists of varying background emerge in the city and province of Venice. Pietro Liberi is the most classical of them, and displays the greatest sensibility and awareness in recapturing some of the compositional and iconographic elements in Cinquecento painting. Some of his mythological compositions, in which the female nude predominates, may appear facile. However, one must grant him the merit of bringing to Venice a new inclination for bright, luminous colours, interpreted in a baroque key, in clear contrast to the dramatic Luminist chiaroscuro. Some artists, such as Lazzarini, Bellucci and Celesti owe him a great deal, and all of them contributed to the formation of a trend which was to develop so considerably at the turn of the century.

At this time, just after mid century, two main currents appear. One style postulates the recovery of festive colouring, richly infused with light. This trend found an example to be followed in the work of Luca Giordano, the brilliant and unpredictable Neapolitan painter who worked at intervals in Venice. The other trend, by contrast, imitates some aspects of painting at the start of the century and attempts to carry on the lesson of Caravaggio by darkening his colours and accentuating the turbulent force of his vision. Followers of this style include the so-called *tenebrosi*, represented most significantly by Giambattista Langetti (of Genoese origin), Antonio Zanchi and finally Giovanni Carlo Loth, German by birth, who eventually learned to moderate his dramatic contrasts between light and shade in favour of softer, more elegant effects, besides brighter colours. Langetti's painting is perhaps the most tormented and violent, with a naturalism that is sometimes cruel, whilst Zanchi seems to be the most circumscribed of the three. His early style was fairly dramatic, but as time went on his statuesque figures were replaced by softer, less definite forms.

Besides these painters there are others working at a purely decorative level who set off the extensive activity involved in painting the great walls of the palaces and churches in the city and province of Venice, according to a custom which became prevalent everywhere during the baroque period. There were also artists who came to Venice from central Italy, such as Ruschi and his two colleagues Coli and Gherardi from Tuscany, and there is also Luca Giordano himself. The presence of all these and others made it possible for painters of different origins to meet; thus, many new ideas were born. In different parts of the Church of S.Zaccaria there are large works by Zanchi, Fumiani and Celesti. Another Venetian church, S.Pantalon, is so widely decorated by Fumiani and his colleagues that the whole building looks like a vast stage set.

In the last decades of the century, the flow of painters went not only into Venice, but also outwards. The Venetians also felt the need to leave their Lagoon and visit other cities, to see what was going on there. To begin with, they gravitated towards the centres of Italian culture such as Bologna, Florence and Rome. But later they preferred to go beyond the Alps to the great European capitals—Vienna, Munich, Paris and London. The last generation of the century, consisting of painters like Bellucci, Ricci, Amigoni and Pellegrini, goes on into the eighteenth century for a time, straddling two epochs. With these painters comes a breakthrough towards themes which are more literary than naturalistic, together with a tendency to re-evoke the great tradition of the sixteenth century and especially its luminous colour. Some, like Fumiani, concentrate on the more decorative aspects of the sixteenth century, whereas others feel the need to broaden their use of colour and to fill their painting with light, abandoning the chiaroscuro to be found in Andrea Celesti. At the same time, such painters as Segala and Pagani were trying out new creative policies, on the impulse of the revival which was clearly taking place by now, not only in Venice but elsewhere in Italy and abroad. Among these Sebastiano Ricci (1659–1734) is

the most outstanding personality, followed by Gian Antonio Pellegrini and Jacopo Amigoni for the importance of their works. Ricci can at first be placed with the seventeenth century, but there is a noticeable tendency in him—a highly cultured man—to model himself on sixteenth century works, particularly those of Paolo Veronese.

The fact of Luca Giordano's presence in Venice has already been mentioned. He was very important partly for the influence he had on the development of Ricci, who starts the splendid era of eighteenth century Venice. Gregorio Lazzarini (Tiepolo's first master) and Bellucci are orientated towards classicism of a pleasant, narrative type, and Balestra too belongs to their group. Ruschi, with his monumental and austere painting, and the two Tuscans Coli and Gherardi had already brought to the Lagoon itself the neo-Venetian style of Pietro da Cortona, the great Tuscan decorative and fresco painter who worked for a long time in Rome. Thus the influence of this baroque painter made itself felt in Venice too, and contributed to the increasing complexity and abundance of trends in its painting. But in this later period there were other painters who made an impression: the dramatic and refined Friulano, Antonio Carneo, and the excellent portrait painter Sebastiano Bombelli, also from the Friuli, who was the master of Fra' Galgario, one of the greatest Lombard artists of the time.

At the end of the century the leadership of Venetian painting is in the hands of Sebastiano Ricci. In his paintings in S.Marziale (1704), the frescoes of the Palazzo Marucelli, Florence (1707) and in the altar-piece of S.Giorgio Maggiore in Venice (1708) he has already laid the foundations for a movement towards the treatment of light which would be welcomed by the new century, and would become the dominant theme for its subsequent creative experiments.

Pietro Zampetti

AVIANI FRANCESCO

Born at Vicenza in about 1662, he was an artist with a big reputation in his life-time. Today he is little known and has only recently received critical attention with the result that a good deal of light has been shed on a figure that nevertheless remains less than clear-cut.

Living in the city of Palladio, he was—as Lanzi observed (1789) strongly drawn to architecture. His canvases were often inspired by visions of cities with wide perspectives where buildings rose after the grand classical manner.

Some nostalgia for the art of Paolo Veronese has also been noted, while influence from Bibbiena settings is not to be excluded. The Vicenza museum pieces show a treatment of landscape with architectural features, after the fashion of Marco Ricci.

In the present state of knowledge, it cannot be said for certain whether Aviani influenced Ricci or the other way about. It is certain that his painting marked a "downward turn in perspective for the Veneto . . . and he initiated a manner that developed especially in mid-century and later with some degree of coherence" (Pallucchini, 1960).

PRINCIPAL WORKS

> Montruglio, Villa Camerini, *Frescoes;*
> Soella, Villa Chiericati, *Frescoes;*
> Vicenza, Civic museum, *Dives and Lazarus;*
> > *Christ among the doctors;*
> > *Miraculous draught;*
> Monte Berico, Santuario, *Frescoes* in refectory.

ESSENTIAL BIBLIOGRAPHY

> Lanzi L., *Storia pittorica della Italia*, Bassano, 1789;
> De Boni F., *Biografia degli artisti*, Venice, 1852;
> De Logu G., *Pittori minori veneti del Settecento*, Venice, 1930;
> Barbieri, Cevese, Magagnato, *Guida di Vicenza*, Vicenza, 1953;
> Ballarin A., *Francesco Aviani*, in "Arte Veneta", 1956;
> Pallucchini R., *La pittura veneziana del Settecento*, Venice-Rome, 1960;
> Barbieri F., *Il Museo Civico di Vicenza*, Venice, 1962.

BALESTRA ANTONIO

Born at Verona on 12 August 1666. His father was a well-to-do merchant and when the son showed an aptitude for painting had him apprenticed to a small local painter of the name of Ceffis at an early age. But his father died and the son was obliged to look after the business which meant giving up art temporarily though he returned to it on a permanent basis shortly after, in 1687 when he was twenty-one.

He removed to Venice and entered the studio of Bellucci. Three years passed and then he was off to Rome where he became Maratta's pupil and in 1694 carried off the prize awarded by the Accademia di S. Luca. His Roman period, which effected him throughout his life, was characterised by an allegiance to the classical manner then in vogue and led in turn to renouncing his Veneto approach to the treatment of colour.

From Rome he went south again to Naples and then back to Verona by way of Bologna. He divided his time between Venice and his birth-place, alternating with visits to Milan and the Emilia. In 1718 he was registered with the guild in Venice and in 1725 was nominated a member of the Accademia di S.Luca in Rome.

He died on 21 April 1740 at Verona where he worked intensively in his prime and also founded a much-frequented school for painters.

The figure of Balestra is rather complex; his doings indicate the urge to find new pictorial outlets, when art was going through a transitional period. As Battisti percipiently observed (1954), his ingrained classical sense did not stop him trying to find new forms, new statements in chromatic terms expressed with a cold remote composure which took him some way from the welter of Baroque whence he emerged.

What he learned from Roman culture (and also Bologna under the ascendency of the Caracci) was useful in the new developments in process at Venice and in the Veneto at the turn of the century. His position is fairly autonomous in respect of the early eighteenth-century artists yet—to consider only one direction—his influence was noteworthy in stimulating Sebastiano Ricci's formative period which was happening at the same time but so very differently.

PRINCIPAL WORKS

> Bergamo, S.Alessandro, *Esther and Assuerus* (1738);
>> Accademia Carrara, *Moses in the bullrushes;*
> Bolzano, Magistrato dei Mercanti, *Earth's riches* (1698);
> Brescia, S.Agata, *The dead Christ and Mary sorrowing* (1724);
>> S.Maria della Pace, *The Virgin and S.Francis de Sales* (1738);
> Fumane Monese, Duomo, *S.Catherine borne to heaven;*
> Innsbruck, Ferdinandum (ex Duomo), *SS.Trinity and saints* (1728);
> Munich, Alte Pinakothek, *Sacrifice of Isaac; Madonna and child;* etc.;
> Pommersfelden, Schönborn coll., *Death of Sophonisba; Venus and Vulcan;*
>> *Moses and Jethro's daughters;* etc.;
> Rovigo, Accademia dei Concordi, *The Immaculate Conception;*
> Venice, S.Cassiano, *Martyrdom of S.Cassian* (1708–10);
>> S.Zaccaria, *Adoration of the shepherds;*
>> Scuola del Carmine, *Rest on the flight;*
>> S.Giovani Evangelista, *Nativity;*
> Verona, Duomo, *Madonna and child with saints* (1712);
>> S.Niccolò, *John Baptist in the wilderness* (1700–2);
>> S.Teresa degli Scalzi, *Annunciation* (1697), etc.

ESSENTIAL BIBLIOGRAPHY

> Pascoli L., *Vite de' pittori, scultori ed architetti moderni*, Rome, 1730–6;
> Cignaroli G. B., *Vita di Antonio Balestra*, Verona, 1762;
> Zannandreis D., *Le vite dei pittori, scultori e architetti veronesi*, Verona, 1891;
> Tarchiani N., *Mostra della Pittura Italiana del Sei e Settecento in Palazzo Pitti*, Milan, 1922;
> Arslan W., *Studi sulla Pittura del primo Settecento Veneziano;*
> Battisti E., *Antonio Balestra*, in "Commentari", 1954;
> Lorenzetti G., *Venezia ed il suo Estuario*, Rome, 1956;
> De Logu G., *Pittura Veneziana dal sec.XIV al sec.XVIII*, Bergamo, 1958;
> Pallucchini R., *La Pittura Veneziana del Settecento*, Venice-Rome, 1960;
> Passamani B., *Aggiunte del Antonio Balestra* in "Arte Veneta", 1962;
> Donzelli C.-Pilo G. M., *I Pittori del Seicento Veneto*, Florence, 1967 (with good bibliography).

BAMBINI NICOLO

Born at Venice in 1651, he had as masters Pietro Liberi and Sebastiano Mazzoni. Through Carlo Maratta, he became drawn to the pro-classical manner and went to Rome to study under him. Zanetti (1771) reckoned this to his great benefit, completing his cultural and artistic education.

He then returned to Venice and embarked on a very busy career with commissions in Palazzo ducale, Palazzo Vendramin-Calergi, Ca' Pesaro where he painted a salon ceiling and lastly in various churches, including S.Zaccaria, S.Maria dei Frari and S.Moisé. His activity is borne out by the record of his name on the painters' guild register in Venice, first in the year 1687 and subsequently in 1721, 1726 and 1730. He died at Venice in 1736 having also worked in Udine, where he frescoed the chapel of Palazzo arcivescovile.

Bambini was an eclectic painter in a transitional period, though not showing awareness of developing requirements. He took little part in the ferment going on in artistic circles and preferred to stay associated with a manner based on academic values of precise drawing and perfect composition.

The *Ca' Pesaro ceiling* appears to achieve competent chromatic results (conditions are not good enough to pronounce judgment on the same); it dates from 1682 and indicates influence from Liberi.

In religious pieces too, like *S.Teresa degli Scalzi* again in Venice, there is convincing evidence of a notable talent in composition and setting which are careful and balanced.

It need only be added that the figure of this artist has not received full expert evaluation in modern times partly because of the poor condition affecting many of the works.

PRINCIPAL WORKS

> Rovigo, Seminario, *Entombment;*
> Udine, Palazzo arcivescovile (chapel), *Frescoes;*
> Venice, Palazzo ducale, Sala dello scrutinio, *Scenes with doge Michiel;*
> > Palazzo Pesaro, *Allegory of Ca' Pesaro* (1682);
> > Palazzo Vendramin Calergi, *Roman scenes;*
> > S.Stefano, *Birth of the Virgin;*
> > Chiesa degli Scalzi, *Two scenes from the life of S.Teresa;*
> > Scuola del Carmine, *Rest on the flight; Annunciation,* etc.

ESSENTIAL BIBLIOGRAPHY

> Zanetti A. M., *Della Pittura Veneziana*, Venice, 1771;
> Lanzi L., *Storia Pittorica della Italia*, Bassano, 1789;
> Moschini G. A., *Guida per la Città di Venezia*, Venice, 1815;
> Zanotto F., *Storia della Pittura Veneziana*, Venice, 1837;
> Lorenzetti L., *Venezia ed il suo Estuario*, Rome, 1956;
> De Logu G., *Pittura Veneziana dal XIV al XVIII secolo*, Bergamo, 1958;
> Mariacher G., N.B. in "La Pittura del Seicento a Venezia" (Exhibition catalogue), Venice, 1959;
> Flores d'Arcais F., *Una Villa affrescata da Bambini*, in "Arte Veneta", 1962;
> Pignatti T., *La Fraglia dei pittori di Venezia*, in "Bollettino dei Musei Civici Veneziani", 1965;
> Donzelli C., Pilo G. M., *I Pittori del Seicento Veneto*, Florence, 1967.

BELLOTTI PIETRO

Born at Volzano on the shores of Garda in 1627, he died at Gargano in 1700. In Venice he was the pupil of Forabosco but soon quit his master and worked in the realist style, terse and trenchant,

characteristic of him. His reputation in this line was considerable with the result that he received many commissions from leading figures, including the duke of Mantua, Ferdinando Gonzaga.

At Venice, among other work he painted a vast canvas in Sala dello scrutinio, Palazzo ducale, depicting the *Capture and destruction of the turkish castle Margariti in Albania*. The topic was not congenial to his temperament and the resultant work is academic and lack-lustre.

The extreme precision of his details—well to the fore when it comes to portrait painting—has raised the question of contact between Bellotti and northern painters. It is possible that he knew Eberhard Keil (called Monsù Bernardo in Italy), who was in Venice 1651 to 1654.

The fact remains, however, that love of the real was innate to Lombard tradition at popular level. Bellotti thus marched in step with the traditional, though to the point of crudeness.

Much admired by Boschini, the classical Zanetti rated him less highly and today he belongs within the limits of an able practitioner of the "Bamboccio" low-life manner, which had a following throughout Europe.

PRINCIPAL WORKS

> Bologna, National gallery, *Heads of old people;*
> Brunswick, Gallery, *Young girl wearing kerchief;*
> Florence, Uffizi, *Self-portrait* (1651);
> Pommersfelden, Schönborn coll., *Old woman reading;*
> Stuttgart, Staatgalerie, *Lachesi* (1654);
> Venice, Palazzo ducale, Sala dello scrutinio, *Capture and destruction of the turkish castle Margariti;*
> > Ca' Rezzonico, *Head of an old man;*
> Vienna, Kunsthistorisches museum, *Well of Koenigstein castle.*

ESSENTIAL BIBLIOGRAPHY

> Boschini M., *La carta del navegar pitoresco*, Venice, 1660;
> > *Le ricche minere della pittura veneziana*, Venice, 1674;
> Zanetti A. M., *Descrizione di tutte le pubbliche pitture della città di Venezia*, Venice, 1733; *Della pittura veneziana*, Venice, 1771;
> Fiocco G., *La Pittura veneziana del Seicento e Settecento*, Verona, 1929;
> Delogu G., *Pittori minori liguri, lombardi, piemontesi del '600 e '700*, Venice, 1931;
> Mayer A., *Paintings by Pietro Bellotti*, in "Burlington Magazine", 1940;
> Donzelli C.–Pilo G. M., *I Pittori del Seicento Veneto*, Florence, 1967 (with further bibliography).

BELLUCCI ANTONIO

Born in 1654, perhaps at Venice, he was a pupil of Zanchi, a painter associated with the "tenebroso" style of the full Venetian baroque; at the same time he was fascinated by the painting of Pietro Liberi, gay and full of light in the sixteenth-century tradition.

There is evidently some allegiance to the painting of Emilia at the time, and the multiform and lively experiments of the neapolitan Luca Giordano.

In 1674 he produced his first important work, the frescoes for Cappella del Beato Franco in the Chiesa del Carmine at Padua. An early work, it nevertheless shows his inclination to light-filled painting as distinct from the burdensome legacy of Baroque in Lagoon art.

After working at Padua and Vicenza, in 1692 Bellucci was engaged on the grand canvas for S.Pietro di Castello, representing *S.Lorenzo Giustiniani praying for Venice to be delivered of the plague*. The treatment of light and shade in the background is baroque in origin, but a soft light steals into some parts of the painting as if foreshadowing the demand for luminosity, the outstanding achievement of Venetian painting in the eighteenth century.

After this, Bellucci began working for the Palatine court circles of Johann Wilhelm, also the prince of Liechtenstein, the court of Vienna and other patrons. In 1699 he was in Vienna and acted as godfather at the baptism of Gian Antonio Guardi. Still in Vienna, he painted a number of works for the Liechtenstein palace, while at Dusseldorf and Beusberg castle he further enhanced his reputation as a decorator and painter of note.

For some twenty-five years he remained working on German soil except for a short spell in Italy, 1705. In 1714 he left Düsseldorf and journeyed to London where he worked in old Buckingham palace and also completed an extant cycle of paintings at Great Witley (Worcestershire). In 1722 he departed from England and went back to his country a famous man. His life came to a close at Soligo in Treviso province, 1726.

PRINCIPAL WORKS

Dresden, Gemäldegalerie, *Madonna and child;*

Dusseldorf, Kunstmuseum, *Anna Maria Luisa di Toscana; Woman in a straw hat; Apotheosis of Johann Wilhelm Pfalz;*

Great Witley (Worcestershire), Chapel, *Nativity, Ascension and Deposition;*

Kassel, Staatliche gallerie, *Rape of Helen; Rape of the Sabines;*

Klosterneuburg, Abbey church, *Vision of S.Augustine; Education of the Virgin* (and other works);

Mellerstain, Lord Haddington, *Paolo Rolli* (1723); *Patrick Hume of Himmergham* (1722);

Munich, Bayerisches staatsgemäldesammlungen, *Wedding of J.-W. Pfalz and Anna Maria Luisa di Toscana* (and many other works);

Oxford, Ashmolean museum, *Family of Darius appeal to Alexander;*

Padua, Chiesa del Carmine, *Frescoes* (1674);

Pommersfelden, Schönborn coll., *Rebecca at the well* (and other works);

Venice, S.Pietro di Castello, *S.Lorenzo Giustiniani* (1692);

Vienna, Liechtenstein palace, *Decorative work in rooms and on staircases: Allegory of history*, dated 1702.

ESSENTIAL BIBLIOGRAPHY

Rapparini G. M., *Die Rapparini-Handschrift der Landes und Stadt-Bibliothek Dusseldorf*, 1709 (ed. 1958, Düsseldorf);

Fanti V., *Descrizione completa di tutto ciò che trovasi . . . della casa di Liechtenstein*, 1767;

Lanzi L., *Storia pittorica della Italia*, Bassano, 1789;

Tarchiani N., *Mostra della Pittura Italiana del Sei e Settecento a Palazzo Pitti*, 1922;

Longhi R., *Un ignoto corrispondente del Lanzi dalla Galleria di Pommersfelden*, 1922, in "Proporsioni", 1950;

Fiocco G., *La Pittura Veneziana del Sei e Settecento*, Verona, 1929;

Arslan W., *Il concetto di luminismo e la pittura veneta barocca*, Milan, 1946;

Watson F., *A Venetian Settecento Chapel in the English Countryside*, in "Arte Veneta", 1954;

Lorenzetti G., *Venezia ed il suo Estuario*, Rome, 1956;

De Logu G., *Pittura Veneziana dal XIV al XVIII secolo*, Bergamo, 1958;
 La Pittura del Seicento a Venezia, Exhibition catalogue, Venice, 1959;

Pilo G. M., *Bozzetti e modelli settecenteschi del Bellucci a Düsseldorf*, in "Arte Veneta", 1959–60;

Pallucchini R., *La pittura veneziana del Settecento*, Venice-Rome, 1960;

Pilo G. M., *Nuovi cicli di affreschi del Bellucci a Padova e a Bassano*, in "Arte Veneta", 1963;

D'Arcais F., *L'attivita viennese di Antonio Bellucci*, in "Arte Veneta", 1964;

Martini E., *La Pittura Veneziana del Settecento*, Venice, 1964;

Donzelli C.-Pilo G. M., *I Pittori del Seicento Veneto*, Florence, 1967 (with full bibliography).

BOMBELLI SEBASTIANO

Born at Udine in 1635, he went to Bologna between 1663 and 1665, where he studied under Guercino. He then visited Florence and Venice, where he examined sixteenth-century painting, especially that of Paolo Veronese, some of whose works he copied as was the custom of the time. He was particularly interested in portraiture, and soon earned a high reputation in this field.

He was very receptive to Flemish art and the various streams of painting, knowledge of which came to Venice from such a diversity of artists in the course of the century, among whom Strozzi. He certainly knew the work of Van Dyck, either at first-hand or through the Genoa painter Carbone. According to Fiocco, he was also influenced by Kupetzky. His fame as a portrait-painter spread beyond the frontiers of Italy and he was invited to work in Vienna at the court, in Munich, as well as some Italian cities, for instance Mantua and Parma.

He had Vittore Ghislandi for a pupil (also known as Fra Galgario), who remained many years with him and whose early work is like enough to the master to be confused with Bombelli. His name was entered on the painters' guild register from 1687 to 1700, and he died at Venice in 1716.

Lanzi (1789) recorded his greatest talent which was for portraiture, the likeness of the subject being backed by sober ornamental details. His colouring was luminous and intense, his composition stately. He gave the art of portrait-painting in Venice a new lease of life, building on the precedents of the sixteenth-century with the tools of latent Rococo. Fine illustrations of his quality, the portraits by him in Palazzo ducale, Venice.

PRINCIPAL WORKS

Brunswick, Gemäldegalerie, *Portrait of a lady;*

Padua, Civic museum, *Portrait of conte Silvio Capodilista;*

Rome, Accademia di S.Luca, *Rosalba Carriera;*

Rovigo, Seminary art gallery, *Three advocates;*

Udine, Civic museum, *Self-portrait* (1786); *Portrait of a gentleman;*

Venice, Palazzo ducale, *The censors Carlo Contarini and Lunardo Donà; The advocates Diedo, Donà and Bembo;*
 Querini Stampalia gallery, *Polo Querini; The procurator Gerolamo Querini;*

Lorenzo Donà della Rose coll., *A senator of the Donà family.*

ESSENTIAL BIBLIOGRAPHY

Malvasia, *Felsina pittrice*, Bologna, 1678;

Zanetti A. M., *Descrizione di tutte le pubbliche pitture della citta di Venezia*, Venice, 1733; *Della Pittura Veneziana*, Venice, 1771;

Lanzi L., *Storia pittorica della Italia*, Bassano, 1789;

Voss H., S.B. in Thieme-Becker, IV, 1910;

Fiocco G., *La Pittura Veneziana del Seicento e Settecento*, Verona, 1929;

Lorenzetti G., *Venezia ed il suo Estuario*, Rome, 1956;

De Logu G., *Pittura Veneziana dal sec.XIV al XVIII secolo*, Bergamo, 1958;

Mariacher G., in "Catalogo della Pittura Veneziana del Seicento", Venice, 1959;

Rizzi A., *Mostra del Bombelli e del Carneo*, (catalogo), Udine, 1964;

Donzelli C.–Pilo G. M., *I Pittori del Seicento Veneto*, Florence, 1967 (with full bibliography).

BENCOVICH FEDERICO

The personality of this artist has been reconstructed, thanks to the efforts of modern experts in particular those of Pallucchini. He was otherwise almost entirely forgotten and his works either left out of account or erroneously attributed to others.

He was born perhaps at Venice, of a family from Dalmatia in 1677. The information about him is slight. As a young man he frequented the school of Cignani in Bologna and went with him to Forlì when he was engaged in frescoing an Assumption for the cathedral there. In this task, he collaborated with his master and also received a commission direct, from the Orselli family, painting a canvas of *Juno* in 1707, extant in what is now called Palazzo Foschi.

After that, he moved further from the teachings of Cignani, readily apparent in his *Juno*. At Bologna, he associated with Giuseppe Maria Crespi whose school was also attended by another Veneto artist, Piazzetta. The chances are that the two young painters worked side by side, and returned to Venice together, about 1711.

The *Bergantino altar-piece*, tentatively dated 1710 by Pallucchini, is a key work for understanding the style of Bencovich further to his Crespi period. At Venice he painted four pieces for the gallery of Schönborn castle, Pommersfelden, perhaps before 1715.

In 1716 he went to Vienna and may have travelled by Milan. In 1720 he returned to Venice where, between 1725 and 1728, he painted an *altar-piece* for the church of S.Sebastiano depicting the *Blessed Pietro Gambacorti*. About 1730 he probably visited Milan, that is to say before the second journey to Vienna; of the Milan episode there is no evidence though the *altar-piece* in the parish church of Verolanuova, showing the *Deposition*, certainly comes at this time. In the Lombard capital, he painted an altar-piece for S.Maria dei Servi, now lost.

From his letters to Rosalba Carriera who befriended him, it transpires that he returned to Vienna for lack of understanding at Venice. In 1733 he was made court painter by the bishop of Bamberg and Wurzburg, Frederick Karl of Schönborn. In 1734 he painted several altar-pieces for the church of the bishop's palace in Wurzburg, subsequently replaced by works of Tiepolo. In the same year, he undertook some paintings for the Wurzburg residence. The signs are that he stayed in Vienna until 1743. Old and weary, and perhaps disappointed of his expectations he then retired to Gorizia where he died 8 July 1753.

Zanetti (1771) noted his qualities and sensitivity and defended Bencovich from the charges made against him, stating that he was "a worthy painter whatever was said of him" and emphasising the rigour with which he approached his art. This way of painting was not understood because it failed

to delight but rather depressed most of those who saw it: all that was wanted in those days was pleasure-giving and gaiety.

To trace the pattern of Bencovich's stylistic development is no easy task; he was receptive in the extreme to the various contemporary streams of influence. In the Bergantino altar-piece which post-dates the comely Juno of Forlì by a few years, the artist demonstrated his ability to adapt and assimilate; under the stimulus of Crespi, he began to stress chiaroscuro henceforward the paramount feature of his work. Some spiritual affinity with Piazzetta may also be adduced in this painting. But the problem ranges wider: the emotive content is dramatic, often rendered by broken lines as if impelled in a desperate spurt, and in itself suggestive of Magnasco, whom he might well have come across during his various sorties into Lombardy though their dating is obscure.

To all these ingredients must be added the Vienna journeys, complicating the artist's outlook still more. It is plain that he soon parted company with Piazzetta: the brush work becomes more fluid, the treatment of mood broadens, colour turns unpredictable by effect of light. The *Miracle of the host*, of Lanzacco, and to a greater extent the Sibiu paintings bear the imprint of Magnasco's influence in the phantasy emotive content. This is taken to the point where Bencovich appears an interesting off-shoot of Lombard-Genoese culture in a Venetian setting. His sojourn in Austria with its abundance of artistic experiments reflected in local art was therefore of considerable importance.

Pallucchini envisaged Bencovich as the artist who caught young Tiepolo's fancy in the formative period after early training under Lazzarini and there is some support for this view. Moreover, he saw in him the inspirer of the Austrian school of full-blown Rococo and in particular of Franz Anton Maulbertsch who certainly seems to have been influenced by the complex personality of this Dalmatian.

Evidently a good deal more research is needed before the picture is made clear, especially regarding his continued stylistic development where closer study should be rewarding. It can, however, be said that in the final period—witness the Wurzburg paintings—the attempt to achieve more controlled luminosity had exhausted his powers, preluding his solitary end in Gorizia.

PRINCIPAL WORKS

> Berlin, Staatliche museen, *Madonna enthroned and saints;*
> Bergantino (Rovigo), Parish church, *Madonna del carmine;*
> Crema, Chiesa della trinità, *S.Francesco di Paola;*
> Forlì, Palazzo Foschi, *Juno;*
> Lanzacco (Udine), Beretta coll., *Miracle of the host;*
> Pommersfelden, Schönborn castle, *Agar and Ishmael; Sacrifice of Iphigenia;*
> Sibiu, Brukenthal museum, *S.Peter healing the sick; Socrates urged to escape from prison;*
> Verolanuova, Borgo S.Giacomo, Chiesa del castello, *Deposition;*
> Venice, S.Sebastiano, *The blessed Pietro Gambacorti;*
> Wurzburg, Residenz, *Sacrifice of Jephthah; Moses and Aaron before pharaoh;*
> Zagreb, Strossmayer gallery, *Sacrifice of Isaac.*

ESSENTIAL BIBLIOGRAPHY

> Guarienti in Orlandi P. A., *Abecedario pittorico*, Venice, 1753;
> Zanetti A. M., *Della Pittura Veneziana*, Venice, 1771;
> Lanzi L., *Storia pittorica dell'Italia*, Bassano, 1781;
> Moschini G. A., *Guida per la citta di Venezia*, Venice, 1815;
> Mariette P., *Abecedario*, in "Archives de l'art français", 1854-7;

Donati L., *Federico Bencovich*, etc. in "Archivio storico per la Dalmazia",
 1929; *Ancora di F. Bencovich*, in "Archivio storico per la Dalmazia",
 1930;
Pallucchini R., *Federico Bencovich*, in "Rivista d'Arte", 1932; *Contributo*
 alla biografia di F. B., in "Atti del R.Istituto Veneto di Scienze, Lettere
 ed Arti", 1933–4; *Profilo di F. B.*, in "La Critica d'arte", 1936;
Goering M., *Unbekannte Werke von F. B.*, in "La Critica d'Arte", 1937;
Wittgen F., *Un nuovo dipinto di F. B.*, in "Critica d'arte", 1938;
Arslan W., *Inediti di F. B.*, in "Emporium", 1943;
Pallucchini R., *La Pittura Veneziana del Settecento*, Venice-Rome, 1960;
Varslan W., *Contribuo al Bencovich e al Bazzani*, in "Commentari", 1962;
Martini E., *La Pittura Veneziana del Settecento*, Venice, 1964;
Jonesco T., *Tre dipinti del Bencovich al Museo Bruckenthal di Sibiu*, in "Arte
 Veneta", 1966;
Pallucchini R., *Postilla al Bencovich*, in "Arte Veneto", 1966.

BONO AMBROGIO

Born probably at Venice and active in the second half of the seventeenth century. Information about him covers the period from 1695 to 1712. He was a pupil of the German painter Karl Loth. His name is linked with only two works extant, namely a *Madonna and saints* in Caerano church (Treviso) and another at Venice in the church of S.Michele in Isola, depicting the *Blessed Michele Pini*.

Zanetti referred to paintings of his on the staircase of the Scuola della Misericordia, on the altar of the Scuola di S.Pasquale Baylon and in S.Francesco della Vigna.

As Pignatti observed, the little altar-piece at Caerano is a modest work and strictly derivative. In the Scholz collection, New York, there is the drawing for this altar-piece, in date of 1695.

ESSENTIAL BIBLIOGRAPHY

 Orlandi-Guarienti, *Abbecedario*, Venice, 1753;
 Zanetti A. M., *Della pittura veneziana*, Venice, 1771;
 Lanzi L., *Storia pittorica della Italia*, Bassano, 1789;
 Pignatti T., *Disegni veneti del Seicento*, in "La Pittura del Seicento a
 Venezia", Exhibition catalogue, Venice, 1959;
 Donzelli-Pilo, *I Pittori del Seicento Veneto*, Florence, 1967.

CARBONCINO GIOVANNI

Born at Venice in the early years of the seventeenth century (precisely when is not known), he was a follower of Metteo Ponzone, a notable late-Mannerist. He went to Rome though the concrete evidence for the visit is lacking. According to some authorities he was confused with Giovanni Carbone who had come from the Marches to live in Rome and was a member of the Accademia di S.Luca.

Lanzi (1789) reported his presence in Rome but deemed it of short duration; Federici on the other hand has stressed the significance of this visit. That he had been to Rome is clear from the manner he favoured. His works show knowledge of Caravaggio, especially in seeking for simple composition; this contrasted with the emphatic and complex treatment of composition featuring in Venice

at the end of the sixteenth century and the early years of the seventeenth. Some experts are of the opinion that he could have become pro-Caravaggio—apart from any journey to Rome—by contact with Ruschi, who was at Venice from 1630. Carboncino figured on the guild register of Venetian artists from 1687 to 1692 and his death probably occurred shortly after.

His painting is not of clear Venetian derivation; it is rather the product of a mixed education. Present-day knowledge of the artist is not deep enough to account for his rise and subsequent development. He looks to be something of a late academic traditionalist after Padovanino (that is to say, looking to the past for examples of clarity and simple composition), with an appreciation of realism. He steered well clear of the emphatic manner then in vogue, likewise of the rather truculent and dark-hued version of neo-Caravaggio put about by Langetti and Zanchi. Carboncino loved simple painting, with no frills and flourishes, almost as it were a "primitive" born after his time.

The return to simplicity was his contribution, while painters all around were in the grip of violence. As Arslan remarked, Carboncino avoided the luminist approach to achieving violent chiaroscural effects; the objects he painted were bathed in clear light, fixed upon the retina in permanent immobility, yet conveying an effect simple and austere at the same time.

His extant works are few, as at present ascribed to him: documented paintings which were once at Venice and Vicenza have been lost.

PRINCIPAL WORKS

> Padua, Ognissanti church, *Visitation* (1681);
> Treviso, S.Niccolò, Two canvases with *miracles of S.Susone;*
> Vicenza, Duomo, *St.Louis king of France gives reliques of the true cross to the blessed Bartolomeo Breganze;*
> Venice, Correr museum, *Francesco Morosini on horseback.*

ESSENTIAL BIBLIOGRAPHY

> Zanetti A. M., *Descrizione di tutte le pubbliche pitture della citta di Venezia,* Venice, 1733;
> Lanzi L., *Storia pittorica della Italia,* Bassano, 1789;
> Moschini G. A., *Guida per la città di Venezia,* Venice, 1815;
> Fiocco G., *La Pittura Veneziana del Seicento e Settecento,* Verona, 1929;
> Arslan W., *Il concetto di luminismo e la pittura veneta barocca,* Milan, 1946;
> Lorenzetti G., *Venezia ed il suo estuario,* Rome, 1956;
> Zampetti P., *La Pittura del Seicento a Venezia,* (Exhibition catalogue), Venice, 1959;
> Savini-Branca S., *Il collezionismo veneziano del '600,* Padua, 1964;
> Donzelli C.–Pilo G. M., *I Pittori del Seicento Veneto,* Florence, 1967 (with further bibliography).

CARLEVARIJS LUCA

Born at Udine on 20 January 1663, his father Leonardo was skilled in science and mathematics, produced a tall map of Udine (1668) and was an architect as well (Mauroner, 1945, p.14). When Luca was only six, his father died and the boy learnt from his father's study by means of Cassandra, an elder sister. In 1679 when Luca was sixteen, the Carlevarijs family left the Friuli and settled in Venice. The new home was on Carmelite property and Luca retained it as long as he lived.

It seems that not long after they arrived Luca departed for Rome, as stated by Moschini (1806, III, p.86). Although supporting evidence is lacking, the probability is that such a visit did in fact take place. He was married at Venice in 1699 so it would have to be at some previous date though for how long is hard to ascertain. However, the visit must have been of some duration and can be reckoned a determining factor in his formation. Moschini said that "at an early age he went to Rome and there set about copying buildings, old and new, for all he was worth, recording them from both inside and out".

After returning from Rome, little time seems to have been spent away from Venice and that was on brief and occasional visits to his birth-place. The witness at his wedding to Giovanna Succhietti, in 1699 as mentioned, was Piero Zenobio; such were the ties of friendship between that house and the artist that he was called "Luca da Ca' Zenobio".

In 1700 his first child, Pietro, was born; the next year came Maria Caterina; in 1703, it was the turn of Marianna Paolina, later a painter and pupil of Rosalba Carriera; on 22 July 1709, Laura. On 13 January following his wife died, after "about six months' fever", no doubt subsequent on the confinement.

His activity as a painter alternated with work as an architect. In 1712 he went to Conegliano to advise on a monastery building, the Priorato di S.Maria del Monte. In 1714, he visited Udine at the invitation of "Magistrato nostro" as a "leading expert on architecture". The purpose was to report on the work in progress at the Duomo in Udine and he wrote that he had a wide experience in that field. In 1727, he made his will leaving his Friuli assets to Pietro, his only son, as goods "of old in my family". After minor bequests to his nephews, the sons of his sister Cassandra, the residue went to his beloved daughters, Caterina, Marianna and Laura. The painter died on 12 February 1729, "at the age of sixty-six, of cerebral disease and an apoplexy" (Mauroner, 1945, p.44). Carlevarijs, noted for a portrait of Bartolomeo Nazari (Ashmolean at Oxford), was "a fine-looking man, rather tall; I knew him personally. He dressed moderately and had a blonde wig" (Temanza, in Mauroner, 1945, p.35).

His friendships were made and kept within the patrician circle and this fact, together with the considerable wealth bequeathed to his children suggests a comfortable standard of living, in part the result of the family background and in part to his own earned income.

The documentary proofs of his activity in Rome at an early period are lacking. The first dated work of the artist does not come before 1703. On 27 May that year he launched his fundamental, massive and trend-setting work, *The buildings and views of Venice, drawn in perspective and engraved.* They comprise one hundred and four etchings, known in three editions and one re-print (Mauroner, 1945) with the addition of two more views, that of the *Seminario* and the *Vescovado* of Treviso. He had previously given some indication of his pictorial inclinations in the early *Bible scenes* from the church of S.Pantaleone, the *Landscapes* of Ca' Zenobio—also at Venice—and the *View* certainly associable with the Roman period.

To this phase belong his first efforts in the direction of "ideal" views, with their blend of elements real and imagined. The pattern was cherished by Marco Ricci, and arose as he worked and as a result of contact with the complex artistic world of Rome. Carlevarijs followed his mind's eye up hill and down dale, beneath skies painted as fresh and tender as the memory of a lost world; he had time for people too, with their troubles and everyday concerns. The contradictions between these aspects of creative work were part and parcel of the complex cultural scene, consequently reflected in his work.

At Venice, he was probably influenced by Heinz the younger, that artist of note; at Rome together with Pannini in his own age-group, he studied the new values of Van Wittel's view-painting. He may have absorbed still more from the Dutchman's visit to Venice, which took place in the year 1694. It is not without significance that his album of views of Venice came out a few years after

Van Wittel began drawing prospects of the city from the life; the evidence of this may be found in the graphic material at the National library in Rome.

Luca's view-painting impressed, first, by the large number of plates which must have meant years of preparatory work; it is however of quite exceptional importance as establishing his claim to priority, despite the impetus to the style having been drawn from Van Wittel. In part trusting to what he had learned from Heinz, he made the environment come alive, telling its own tale in terms so economical and concise that it became more a chronicle than a mere view-painting. His scope necessarily widened to embrace all walks of life. Abundant drawings of figures in all kinds of attitudes, nobleman and commoners, prelates and poor men, alone or more frequently in groups, bear witness to his interest. They are simply drawn and catch the characteristic pose so neatly as to provide moral comment.

The paint material of this artist from the Friuli was free-running, fresh and near-tender in tone; in this respect, again influence of Van Wittel was at work. But his flair for conveying objective reality, more appreciable in the figures perhaps than the buildings which form the setting, produced a record of specific historical context. This was going on at the very time Canaletto was about to embark on his prodigious life-work.

PRINCIPAL WORKS

>Birmingham, City art gallery and museum, *Lord Manchester, British ambassador entering Palazzo ducale;*
>Dresden, Staatliche Gemäldegalerie, *Arrival of the Imperial ambassador count Colloredo in Palazzo ducale;*
>Hartford, The Wadsworth Atheneum, *The votive bridge for the feast of the Madonna della salute;*
>Oxford, Ashmolean museum, *Piazzetta and library;*
>Rome, Emo Capodilista coll., *Punta della Dogana, Bacino & S.Giorgio;*
>Rome, National gallery (Palazzo Corsini), *Molo & Zecca with Punta della Dogana; Molo and Palazzo ducale;*
>Venice, Ca' Rezzonico, *View of river bridge;*
>Correr museum, *S.Maria Formosa; S.Rocco; Palazzo Moro-Lin by S.Samuele;*
>Italico Brass coll., *Piazza S.Marco;*
>Vicenza, Civic museum, *Landscape and architectural features.*

ESSENTIAL BIBLIOGRAPHY

>Orlandi P., *Abecedario pittorico* (with additions of P. Guarienti), Venice, 1753;
>De Rinaldis G., *Pittori friulani*, Udine, 1796;
>Damerini G., *I pittori veneziani del Settecento*, Bologna, 1929;
>De Logu G., *Pittori veneti minori del Settecento*, Venice, 1930;
>Mauroner F., *Luca Carlevarijs*, Venice, 1931;
>Pallucchini R., *La Pittura Veneziana del Settecento*, Venice-Rome, 1960;
>Rizzi A., *Disegni, incisioni e bozzetti del Carlevarijs*, (Exhibition catalogue), Udine-Rome, 1963-4;
>Zampetti P., *I Vedutisti Veneziani del Settecento* (Exhibition catalogue), Venice, 1967;
>Rizzi A., *Luca Carlevarijs*, Venice, 1967 (with good bibliography).

CARNEO ANTONIO

Born at Concordia Sagittaria in the province of Udine, in 1637; his father Giacomo il Vecchio was also a painter. Information about him stems in the main from Guarienti who wrote his biography and made use of details received from Pavona, a pupil of Carneo.

His life was uncomplicated and untroubled by travelling. He seems to have lived for a long while at Portogruaro after working for count Caiselli, his patron, who got paintings in return for his accommodation. Quite recently, the scholar Benno Geiger (1940) became interested in the artist and went to the Caiselli's where he found over eighty paintings which had been there since Carneo gave them to his benefactor in Portogruaro. The artist's death dates from 1692, and took place in Portogruaro in conditions of great misery.

Second to Pordenone, no painter of the Friuli had the fame or the talents of Carneo. He certainly looked to the example of his great predecessor from the same area, but was not unmindful of the master-pieces of Tintoretto and Veronese. These earlier artists had a considerable hand in his formative period though Carneo was also influenced by painters active at the beginning of the century, such as Padovanino. He was especially close to the personality of Pietro Vecchia, whose expressionist style was often dramatic to the point of violence.

The choice of subjects made by Carneo showed intense concern for facets of everyday life. His interest was often captured by ordinary people, the aged that is to say the careworn, and their suffering he conveyed with near-aggressive feeling. The artist was moving in the direction of a kind of painting on the increase at Venice after the visit of Bernardo Keil there, from 1651 to 1654.

In the second half of the century, a new stream of painters had come into being called the "Neo-tenebrosi". Caravaggio was their father figure, the leading exponents being men of the mark of Langetti of Genoese origin, Zanchi and the German Karl Loth. Yet the personality of Carneo cannot be confused with these artists. He preferred a luminosity that was diffuse rather than violent chiaroscuro, and his deep involvement clearly distinguishes him from the rest.

In respect of the treatment of light, there is some echo from the art of Veronese. His sense of involvement at times of dramatic impact, at others more tenuous and less urgent, came from the baroque cultural situation. He is undoubtedly one of its main mouth-pieces in the world of Venetian painting. His style evolved from a stance associated with the modes of Padovanino towards a much more reactive and introspective sensitivity. Although he lived at provincial level, he showed tremendous potential in responding so keenly to the cultural criteria of the time.

His stature may be gauged from a few works: the *Education of the Virgin* in the church of S.Cristoforo at Udine; the *Ordeal by poison* of the Callegaris collection at Terzo d'Aquileia; and last, the splendid *Lucrece dying* entirely carried out in livid tone impasto. Lanzi (1789) referred to him as "genial . . . with a good head for drawing and a happy hand with colour". Modern authorities from Fiocco to Geiger and Pallucchini have provided a revaluation of his personality, individual and deeply dramatic.

PRINCIPAL WORKS

 Besnate (Varese), Parish church, *S. Thomas distributing bread to the poor;*
 Gemona (Udine), Mazzanti coll., *Death of Lucrece;*
 Leningrad, Hermitage, *Archimedes;*
 Milan, Brera gallery, *Old woman with winder;*
 Rome, Jacopino del Torso coll., *The fortune-teller; Seduction* (and other works);
 Udine, Civic museum, *The rover; Meditation; The Holy family venerated by*
 Udine authorities; Portrait of Ferdinando di Prampero;
 Leonardo Caiselli coll., *Allegory of abundance;*
 Warsaw, National museum, *Lucrece dying.*

Orlandi P. A., *Abecedario pittorico*, Florence, 1776;

Lanzi L., *Storia pittorica dell'Italia*, Bassano, 1789;

Di Maniago F., *Storia delle Belle Arti Friulane*, Udine, 1823;

Voss H., in Thieme-Becker VI, 1912, under appropriate heading;

Fiocco G., *La Pittura Veneziana del Seicento e del Settecento*, Verona, 1929;

Geiger B., *Antonio Carneo*, Udine, 1940;

De Logu G., *Pittura Veneziana dal XIV al XVIII secolo*, Bergamo, 1958;

Mariacher G., in "La Pittura del Seicento a Venezia", (Exhibition catalogue), Venice, 1959;

Rizzi A., *Antonio Carneo*, preface by L. Coletti, Udine, 1960;

Rizzi A., *Mostra del Bombelli e del Carneo* (catalogo), Udine, 1964;

Donzelli C.-Pilo G. M., *I Pittori del Seicento Veneto*, Florence, 1967 (with full bibliography to that date).

CARPIONI GIULIO

Born at Venice in 1612, he is one of the figures most representative of the Venetian seventeenth century. His classical traits, constantly maintained throughout his long career, undoubtedly derived from the formative period when he frequented the studio of Alessandro Varotari, called Il Padovanino (q.v.). No works remain from his youth and hence Venetian phase.

In about 1638, the artist left Venice for Vicenza and may have stayed for a while at Padua in between. It is possible he was in contact with painting at Bologna and that he was influenced by Reni and Simone Cantarini. The position of Carpioni in respect of Veneto painting of the seventeenth century is fairly controversial and self-standing compared with artists like Pietro Vecchia and Maffei who deemed colour a basic organ of expression.

He maintained a much more balanced view. Graphic definition was to be given figures, in the attempt to achieve formal equilibrium and a composure which remain the key elements in his artistic activity. The stress on line was in part due to his interest in graphics. He was among the greatest of seventeenth-century engravers. The degree of luminosity which he produced with the technique marked an innovation amidst the torment and darkness of the baroque period. There is no doubt that some aspects of the art of Carpioni were influential in encouraging the breakthrough of new trends in Venice during the seventeenth century.

The position of Carpioni within the Venetian setting, with his near-classical manner, was utterly untainted by immediate influence from other sources. It therefore indicated a breadth of outlook and a complex fabric of tendencies in Venetian painting of the seventeenth century. His pet subjects were mythological, though he also went in for altar-pieces, portraits and so on. In the scenes from fable, his literary interpretations comprised new turns of phrase; the sense of gaiety and abandon implied a convinced classical awareness, far removed from the baroque repertory, so frequently couched in terms of drama and violence.

His treatment of colour was always controlled, not to say contained within rapports of restricted luminosity; his skies were always blue. This classical feeling which to some extent cut him off from the Veneto world of his time may have been due to a youthful journey to Rome (postulated by Longhi). This would have enabled him to gain first-hand knowledge of the new departures of Caravaggio, at the same stage deepening his obvious natural inclination in the classical sense. The fusion between Caravaggio's realism, which he could also have grasped through the work of Saraceni and other artists of his acquaintance, and his innate classicism produced the art of Carpioni.

In sensitivity and manner he stands among the most typical representatives of the Venetian seventeenth-century and among those closest to the development in local painting which occurred at the close of the century.

He was very active at Vicenza and spent a good many years of his life in that city. He in fact died in 1679.

His activity was intense. His mythological pieces, his bacchanals were highly thought of by contemporaries, as Orlandi put on record. "Of such scenes, the artist was the most exuberant maker ever, harmonising colour and concept to perfection". Lanzi (1789) appreciated the value of Carpioni's art, preferring him to Maffei who was the other great artist working at Vicenza and moving towards a totally different manner. He stated that Carpioni was a pupil of Padovanino and mentioned that "in many noble houses were found bacchanals, dream-pieces, capricci, fables and scenes from history of a fine spirit and savour with regard to colour material".

Of late years the experts have had a closer look at the work of Carpioni. It was shown to advantage at the great Exhibition of Venetian seventeenth-century painting held in 1959; Giuseppe Maria Pilo then produced a painstaking monograph, summing up Carpioni thus: "The two poles of Carpioni's phantasy find expression by escaping into remote mythical regions on the one hand and on the other by uninterrupted and rather tiring attempts to find stylistic solutions. He persuaded himself that the secret lay in classical treatment of colour (neo-Titianesque) beneath a cold shower of light that the realism of Caravaggio had made actual. On this difficult two-fold path, he was sometimes able like no one else in the Veneto at the period to achieve apparent heights of felicity unaligned with the natural reality. In this, he presented motifs particular most of all to the coming century".

PRINCIPAL WORKS

Ancona, Civic art gallery, *Contest of Muses and Graces;*
Bergamo, S.Spirito church, *Deposition;*
 Carrara academy, *Birth of Adonis; Drunkenness of Silenus;*
Budapest, Fine arts museum, *Leander borne away by the Nereids; Satyr and nymphs; Feast of Venus;*
Chicago, Art institute, *Sacrifice of Polyxena;*
Dresden, Gemäldegalerie, *Leto changing Lycian peasants into frogs; Bacchus and Ariadne;*
Florence, Uffizi gallery, *Self-portrait; Neptune pursuing Coronis;*
 Donzelli coll., *Offering to Venus;*
Milan, S.Bernardino dei Morti, *Christ and the adulteress;*
 Brera gallery, *Self-portrait;*
 Sforza castle, *Head of Venus;*
Padua, Servi church, *Massacre of the innocents;*
 Civic museum, *Death of Leander;*
Vicenza, Monte Berico sanctuary, *Madonna and saints;*
 Carmini church, *Martyrdom of SS.James and Philip;*
 SS.Felice & Fortunato church, *Martyrdom of S.Florian;*
 Civic museum, *Portrait of a woman; The good Samaritan; Soap bubbles; The lady lutenist;*
Villa di Montecchio Maggiore, La Cordellina, *Death of Leander; Feast of Venus;*
Venice, Accademia gallery, *Triump of Silenus;*
Vienna, Kunsthistorisches museum, *Realm of Hypnos.*

ESSENTIAL BIBLIOGRAPHY

Boschini M., *Le Minere della Pittura*, Venice, 1664; *I gioielli pittoreschi virtuoso ornamento della città di Vicenza*, Venice, 1676;

Orlandi P. A., *Abecedario pittorico*, Venice, 1704 (ed. of 1753 with additions by P. Guarienti, p.311);

Zanetti A. M., *Della Pittura Veneziana*, Venice, 1771;

Lanzi L., *Storia Pittorica della Italia*, Bassano, 1789;

Fiocco G., *La Pittura Veneziana del Seicento del Settecento*, Verona, 1729;

De Logu G., *La Pittura Italiana del Seicento;*

Arslan E., Catalogo delle cose d'arte . . ., Vicenza, I, *Le chiese*, Rome, 1956;

Zampetti P., *Pittura Italiana del Seicento*, Bergamo, 1960;

Pilo G. M., *Carpioni*, Venice, 1961 (with full bibliography);

Donzelli G., Pilo G. M., *I Pittori del Seicento Veneto*, Florence, 1967 (with bibliography to that date).

CELESTI ANDREA

Born at Venice in 1637, his first master was Ponzone. He then became a pupil of Sebastiano Mazzoni on the evidence of Temanza. It is plain that he also looked to Maffei and the works of Luca Giordano. Among the artists in practice during the second half of the seventeenth century, he is a most sensitive instance, moving in the direction of a new pictorial quality, clear and luminous, which affords a marked contrast with the "Tenebrosi" (like Langetti and Zanchi) who were carrying on the late Caravaggio style and treating colour as subsidiary to accentuated light and shadow.

The first work of Celesti was done for the chapel Della pace in the basilica of SS.Giovanni & Paolo in Venice, all now lost. The pieces dated from 1675 and were referred to by Zanetti and by Cochin (1758) in very complimentary language. They remarked on the potential from the point of view of composition, the soft and fluctuating brush-stroke manner, the strong sense of colour. As Pilo commented (1957), "Celesti owed the largest debt to influence from Luca Giordano, mentioned above, further to a start on local level. The Neapolitan painter brought him to one of most effective sources of renewal in the annals of Venetian seventeenth-century painting, then in the fourth generation".

After 1681, he painted some canvases for the hall called Quarantia Civil Vecchia in Palazzo ducale; these were followed by two great lunettes for the church of San Zaccaria, also in Venice. These products afforded evidence of the full measure of his personality. Linked by training with the great Venetian tradition of the sixteenth century (and especially in violently contrasted tonal values, with Tintoretto), he adopted a brush technique with the colours in ferment between light and shadow, the tendency being always to heighten the clear ones until they were almost deadened and devoured in light. Thus he put on record his vision, hallucinatory and very baroque.

After 1688, the artist left Venice through a dispute with the doge Alvise Contarini who had remained unappreciative of one of his paintings. He went to lake Garda and Brescia and was kept very busy painting there. His activity at this period was especially happy. His colours clarified and became quite festive, freely interplaying with light after the example of Mazzoni and Maffei but still within arm's breadth of the great Venetians of the sixteenth century.

His work in the cathedral at Desenzano and the decoration of the cathedral at Toscolano speak effectively for this period of Celesti's career. He "produced sumptuous scenes in architectural settings after Veronese's manner; the lavish treatment of form outdistanced drawing which seldom

showed in marking out his vast tracts of colour laid on with a generous hand, well-filled and free-moving brush, lightly veiled in the shadows and mezzo-tints" (Pilo, 1967).

In 1700 he returned to the Veneto and worked to capacity at Treviso and Asolo (Villa Rinaldi Barbini at Casella d'Asolo) and then once more in Lombardy at Verolanuova, in the parish church. He died in the district of Garda, apparently at Toscolano, in the year 1712.

Celesti had a strong personality. His late works in particular showed the stress that he placed on the role of light in painting. His luminism in fact led to his creating an atmospheric density within which objects became involved to the point of shedding the burden of their own consistency. As a result he was a most note-worthy artist and among those anticipating the tremendous innovations to follow in the Venetian painting of the new century.

PRINCIPAL WORKS

Bagolino, Parish church, *S.George* (1703);
Bergamo, S.Pietro, *S.Anthony of Padua;*
Bogliaco (Brescia), Parish church, *The guardian angel;*
 Palazzo Bettoni Cazzago, *Bible scenes and Roman scenes;*
Brescia, SS.Faustino & Giovita church, *Madonna and child with four saints;*
Casella d'Asolo (Treviso), Villa Rinaldi-Barbini, *Fresco decorative scheme with bible and mythological scenes;*
Desenzano, Cathedral, *Resurrection;*
Dresden, Gemäldegalerie, *The Israelites worshipping baal;*
Gargnano, S.Rocco, *S.Albert;*
 Convento dei Minori, *Annunciation;*
Maderno, Parish church, *Assumption;*
Padua, Palazzo Conti, *Belshazzar's feast;*
Potsdam (Berlin), Sanssouci, *At table in Simon's house; Flight of Lot from Sodom;*
Rovigo, Rotonda, *Allegory of Giovanni Giustiniani;*
Salò (Brescia), Duomo, *Adoration of the Magi* (and other altar-pieces);
Stuttgart, Staatsgalerie, *Pool of Bethesda;*
Toscolano (Brescia), Duomo, *Fall of Simon Magus; S.Peter freed from prison; Adoration of the shepherds* (and other altar-pieces);
 Palazzo Delay Mafizzoli, *Loth and his daughters; Potiphar's wife; Hagar in the wilderness* (and other bible scenes);
Venice, Ospedaletto church, *Virgin and saints;*
 S.Zaccaria, *The pope, emperor and doge receiving the body of a saint; Pope Benedict III visiting the monastry;*
 Palazzo ducale, *Decorative scheme* in Quarentia Civil Vecchia;
Verolanuova (Brescia), Parish church, *Martyrdom of S.Lorenzo* (and other altar-pieces).

ESSENTIAL BIBLIOGRAPHY

Zanetti A. M., *Descrizione di tutte le pubbliche pitture* della città di Venezia, Venice, 1733;
Orlandi P. A.–Guarienti P., *Abecedario pittorico*, Venice, 1753;
Cochin ch.N., *Voyage d'Italie*, Paris, 1758;
Zanetti A. M., *Della pittura veneziana*, 1771;
Lanzi L., *Storia pittorica della Italia*, Bassano, 1789;

Fiocco G., *La pittura veneziana del Seicento e Settecento*, Verona, 1929;

De Logu G., *Pittori minori liguri*, etc., Venice, 1931;

Arslan E., *Studi sulla pittura del primo Settecento veneziano*, in "La Critica d'Arte", 1935–6;

Ivanoff N., *Gli affreschi del Liberi e del Celesti*, etc., in "Arte Veneta", 1949;

Mucchi A. M.–Della Croce C., *Il pittore Andrea Celesti*, Milan 1954;

Zava Bocassi F., *Gli affreschi del Celesti a Villa Barbini*, etc., in "Arte Veneta", 1965;

Donzelli C.–Pilo G. M., *I pittori del Seicento Veneto*, Florence, 1967 (with further bibliography).

CERVELLI FEDERICO

Born at Milan in 1625, he removed to Venice after a first Lombard grounding. He was entered on the guild register of Venetian painters from 1689 to 1694, though it appears he was at Venice about mid-century. However that may be, works by him were well enough known in 1674, when cited by Boschini.

The death of Adonis and other canvases at the Querini Stampalia gallery, Venice show a performance after the pro-classical manner of Pietro Liberi. Subsequently, he found the manner—dramatic and exotic—of Mazzoni appealing, likewise Celesti's personality with its open preaching of luminosity and colour impasto. It is clear that both artists in turn were influenced by Luca Giordano, so strong a trend-setter for many Venetian painters in the latter half of the century.

There used to be work by Cervelli at Venice, in the Oratorio dei Bottegari, S.Cassiano church and elsewhere, now gone. Cervelli was Sebastiano Ricci's first master and as such embarked him on his long campaign to conquer light, a gift so largely left out of account by the seventeenth century.

PRINCIPAL WORKS

Bergamo, S.Maria Maggiore, *Noah's burnt-offering after the Flood* (1678);

Este, S.Maria della Salute, *S.Luigi Gonzaga's First communion;*

Venice, G. Cini foundation, *Massacre of the innocents;*

 Querini Stampalia foundation, *Venus and Adonis; Death of Adonis; Orpheus and Eurydice; Pan and Syringe.*

ESSENTIAL BIBLIOGRAPHY

Boschini M., *Le ricche minere della pittura veneziana*, Venice, 1674;

Zanetti A. M., *Descrizione di tutte le pubbliche pitture della città di Venezia*, Venice, 1730;

Orlandi P. A.–Guarienti P., *Abecedario Pittorico*, Venice, 1753;

Lanzi L., *Storia pittorica della Italia*, Bassano, 1789;

Fiocco G., *La Pittura Veneziana del Seicento e Settecento*, Verona, 1929;

De Logu G., *Pittura veneziana dal XIV al XVIII secolo*, Bergamo, 1958;

Donzelli L.–Pilo G. M., *I Pittori del Seicento Veneto*, Florence, 1967 (with further bibliography).

DIAMANTINI GIUSEPPE

Born at Fossombrone in the Marches, in 1621, he made his way to Bologna where he trained at the school of the Caraccis. Moving on to Venice, he remained for a long while working in the city, contributing his Bologna culture so deeply rooted in the classical spirit.

According to Melchiorri, his compositions on mythological and allegorical subjects were especially appreciated. In this regard, he helped diffuse a manner which was to achieve a wide following and bear fruit at the close of the century. At Venice, the artist was highly thought of by the patrician families who patronised him until 1698, when he went back to his native place and died there on 11 November 1705.

Boschini in the "Minere" (1664) referred to a painting of S.Francis and the angels, in the church of San Cassiano in Venice; in the same author's "Ricche Minere" of 1674, this work was attributed to Ruschi. Zanetti (1733) explained that Diamantini's picture in that church was a *Deposition*, whereas the S.Francis was indeed by Ruschi. Unfortunately, both works are lost.

Other pieces cited by Lanzi have been lost sight of; many of his drawings exist, however, dispersed in many collections. Some of these which are still unpublished, may be found in the holdings of S.Maria in Via church at Camerino in the Marches. Pignatti (1959) remarked some affinity between the "writing" of Diamantini and that of Carpioni.

Diamantini had two brothers, Leandro and Aldobrando, both of whom worked at Venice as far as is known.

KNOWN WORKS

> Dresden, Gemäldegalerie, *David with head of Goliath;*
> Fossombrone, S.Filippo sacristy, *SS.George and Sebastian;*
> Venice, S.Giovanni Grisostomo, *Eternal father in glory with angels;*
> > S.Moisé, *Adoration of the shepherds.*

ESSENTIAL BIBLIOGRAPHY

> Boschini M., *Le Minere della Pittura*, Venice, 1664; *Le Ricche Minere della Pittura Veneziana*, Venice, 1674;
> Malvasia C. C., *Felsina pittrice* etc., Bologna, 1679;
> Zanetti A. M., *Descrizione di tutte le pubbliche pitture della citta di Venezia*, Venice, 1733;
> Lanzi L., *Storia pittorica della Italia*, Bassano, 1789;
> Vernarecci A., *Di tre artisti fossombronesi*, in "Fossombrone dai tempi antichi ai nostri", 1913, II;
> De Logu G., *Pittura Veneziana dal secolo XIV al XVIII secolo*, Bergamo, 1958;
> Pignatti T., *La Fraglia dei Pittori di Venezia*, in "Bollettino dei Musei Civici Veneziani", Venice, 1965;
> Donzelli C., Pilo G. M., *I Pittori del Seicento Veneto*, Florence, 1967 (with further bibliography).

DORIGNY LUDOVICO

A French artist, he was born at Paris on 14 June 1654. In his native city, he trained in the school of Le Brun. But at the early age of seventeen, he left France and went to Italy. There, he spent four years at Rome and then after travelling through various places in that country he settled at Venice for a decade or so. Many works were produced by him during this time, including the frescoes for Ca' Zenobio. Zanetti praised the quality of his painting, mentioning the great fresco which he did for the church of S.Silvestro.

In 1705, he removed to Verona and it became his second home. He worked there for a considerable period and extended his activities to Vicenza, Padua, Treviso, Cittadella and Udine as well. But

prince Eugene of Savoy invited him to Vienna and so he left Italy; in 1740 he was back in Paris and made a welcome member of the Academy. Returning to Verona, he died there in 1742.

Modern experts have seen his personality under different aspects. Undoubtedly, he was influenced by Roman culture based on the pro-classical after Carlo Maratta. Other elements, of chiaroscuro, he absorbed after Antonio Zanchi while appreciative of the new treatment of colour in a luminous key explicit in the art of Luca Giordano.

It is typical of his position that for a while the famous Angel Raphael series in the church of that name at Venice were attributed to him; the consensus of opinion then assigned them to Francesco Guardi; latterly, they have been correctly restored to their creator in the person of Gian Antonio Guardi.

Dorigny was in essence a decorative painter most at home on large-scale frescoes, the composition of which was on the complex side but nevertheless executed in competent manner.

PRINCIPAL WORKS

> Padua, Servi church, *Madonna and dead Christ;*
> > Duomo, *Annunciation;*
> > Palazzo Cavalli, *Frescoes* in upper room;
> Udine, Palazzo arcivescovile, *Frescoes* above stair well;
> > Duomo, *Frescoes* with saints in glory, Resurrection and Ascension;
> Venice, Palazzo Zenobio, *Frescoes;*
> > Palazzo Tron, *Frescoes;*
> Verona, S.Luca, *Manna from heaven;*
> > S.Nicolò, *S.Joseph in prison;*
> > Civic museum, *S.Louis* series;
> Vicenza, Palazzo Trissino town hall, *Frescoes.*

ESSENTIAL BIBLIOGRAPHY

> Dal Pozzo G. B., *Vite dei pittori . . . veronesi,* Verona, 1718;
> Orlandi P., *Abecedario pittorico,* Bologna, 1719;
> Dezallier D'Argenville, *Vite dei pittori,* Paris, 1762;
> Zanetti A. M., *Della Pittura Veneziana,* Venice, 1771;
> Lanzi L., *Storia pittorica della Italia,* Bassano, 1789;
> Weber S., *Artisti trentini,* etc., Trent, 1933;
> Barbieri-Cevese-Magagnato, *Guida di Vicenza,* Vicenza, 1953;
> Donzelli C., *I Pittori Veneti del Settecento,* Florence, 1957;
> Ivanoff N., *Contributie L. Dorigny,* in "Emporium", 1960;
> Menato G., *Contributi L. Dorigny,* in "Arte Venete", 1967.

FERRARI LUCA

Born at Reggio Emilia on 19 February 1605, he was in youth close to Tiarini. Sources generally concur as to an apprenticeship under Guido Reni though productive of little more than "general benefits in fairly superficial deference to type of manner and canon of the ideal". (Arcangeli, 1959, p.136).

His real training is ascribable to a group of artists who were working in Chiesa della Ghiara at Reggio: namely, Spada, Bonone, Gavassetti, Guercino and also Tiarini. Lanzi made reference to his grandeur of scale and Arcangeli has pointed out that this was due to these painters' influence in his youth, the building being so vast that ample narrative was a requisite in pictorial terms.

The painter soon left the Emilia and went to Padua where he made new contacts with local work, especially that of Stroiffi, Strozzi's pupil and imitator, and Maffei whom he assisted in decorating the ceiling of the Filippini church. In 1639 he belonged to the painters' guild in Padua, from an entry in the register; in 1644 he returned to Reggio to join in the task of painting the Ghiara church. He completed the decoration of the vault and in so doing, his major work.

He soon returned to Padua and went on working there until 1654, the year he died.

In "Carta del Navegar pitoresco", Boschini remarked: But he is a Venetian, not from Reggio. A compliment was intended, of course but it is an evaluation also, acknowledging how the colour of the Lagoons had drawn him to express his artistic vision in terms at once effective and impressive.

PRINCIPAL WORKS

 Battaglia (Padua), Villa Emo Capodilista, *Origins of Padua* and other frescoes (1650);
 Bologna, National gallery of art, *Nero, Octavia & Poppaea;*
 Carpi, Duomo, *Christ and S.Peter* (1646);
 Este, Chiesa arcipretale, *Madonna and child with saints;*
 Modena, Duomo, *Ascension;*
 Galleria estense, *Assumption;*
 Padua, S.Antonio, *Deposition* (1651);
 Civic museum, *Caritas;*
 Reggio Emilia, S.Pietro, *Baptism of Christ* (1649) and other works.

ESSENTIAL BIBLIOGRAPHY

 Scannelli F., *Il microcosmo della pittura*, Cesena, 1657;
 Boschini M., *La carta del navegar pitoresco*, Venice, 1660;
 Mariette P. J., *Abecedario . . .*, 1771, in "Archives de l'art francais", 1853-4;
 Lanzi L., *Storia pittorica della Italia*, Bassano, 1789;
 Moschini G. A., *Guida per la città di Padova all'amico delle belle arti;*
 Arslan W., *Inventario degli oggetti d'arte d'Italia: Padua province*, Rome, 1936;
 Degani M., *Mostra di Luca da Reggio nel III° centenario della morte* (Exhibition catalogue), Reggio Emilia, 1954;
 Pallucchini R., *Contributi alla Pittura Veneziana del settecento in* "Arte Veneta", 1962;
 Savini-Branca S., *Il collezionismo veneziano nel Seicento*, Padua, 1964;
 Donzelli G.-Pilo G. M., *I Pittori del Seicento Veneto*, Florence, 1967 (with further bibliography to date).
 D'Arcais F., *Le decorazione della Villa Rezzonico-Barharige e Novente Vicentini*, in "Arte Venete", 1968;

FORABOSCO GIROLAMO

Born at Padua between 1604 and 1605, he was trained at the school of Padovanino. Thus he learned to love sixteenth-century painting and was indebted to it though not overwhelmingly so. For he was also open to contemporary developments and more keen than commonly credited in following the work of painters active at Venice during his formative phase. There is no doubt that he was influenced by Strozzi; some of his fiery, festive tones evidently derive from the "priest of Genoa". In his prime, he was not unaffected by Mazzoni to give one instance. The great Malamocco

painting, a fairly late work it would seem, does in fact reveal this source in the brush-stroke which is fresh and free to effervescing, the expanded form almost bubbling over.

His natural inclination was for portraiture; a few large-scale compositions are attributable to him, including the two canvases in the Chiesa dei Tolentini, Venice, painted after 1654, the year he moved to Venice. Over-insistence has been placed on his pro-Titian style of portrait painting; if there is one painter who interpreted his age, participating to the full in the way of life of the eighteenth century, then Forabosco is the man, perhaps the leading portrait painter of the Veneto during that century.

Some of his female figures have in fact been taken for work by Velazsquez. His paint material is "pastoso", the colouring kind; the tones of grey and rose, laid on light and transparent, these belong to the great Spaniard's palette. A painter therefore not rooted in the past but of his own time, and indeed representative of the cultural circles in which he moved.

Mention has been made of influence from Bologna, and from Albani in particular, partly as a result of indications in the sources (see Fiocco, 1929, p.32 and Pallucchini, 1945, p.109); if such influence existed, it must have been marginal. What drew him most was the final phase of Strozzi and not only the art of Mazzoni.

Forabosco's masterpiece is undoubtedly the *Miraculous rescue* in Malamocco parish church. As Fiocco remarked (1929, p.33), this canvas was referred to by Boschini in the second edition of his "Ricche minere" book; it was therefore after 1664 and before 1674. Apart from the unmistakable echo of Strozzi—in his final phase—the soft, clear light-filled painting is notable also for being open to the influence of the most genial exuberant painter in Venice at that time, namely Sebastiano Mazzoni. Forabosco, however, interprets the various streams of influence in so far as he reacts to them, that is to say more by way of acknowledgement than actual imitation of either. The scene of the rescue is a series of portraits by the sea, rather than a real composition; but here the artist's personality found full and confident expression. His keen eye for the living reality, quick to register any turn of mind, was given free rein in this work.

Forabosco's importance was indicated particularly on the occasion of the Seventeenth-century art exhibition held at Venice in 1959; the painter died at Padua in 1679.

PRINCIPAL WORKS

> Dresden, Gemäldegalerie, *Madonna and five saints;*
> Florence, Uffizi gallery, *Female portrait;*
> Malamocco (by Venice), Parish church, *Miraculous rescue;*
> Pommersfelden, Schönborn collection, *Samson and Delilah;*
> Rome, National gallery, *Menichina of Padua;*
> Rovigo, Concordi academy, *Joseph and Potiphar's wife;*
> Venice, S.Nicolò da Tolentino, *S.Francis in ecstasy;*
> > Doge's palace, *Portrait of doge Contarini;*
> > Querini Stampalia gallery, *Portrait of a lady;*
> > Correr museum, *Portrait of a noblewoman;*
> Vienna, Kunsthistorisches museum, *Portrait of a gentlewoman.*

ESSENTIAL BIBLIOGRAPHY

> Boschini M., *La carta del navegar pitoresco*, Venice, 1660; *Le ricche minere della pittura veneziana*, Venice, 1674;
> Zanetti A. M., *Descrizione di tutte le pubbliche pitture della città di Venezia*, Venice, 1733;
> Orlandi-Guarienti, *Abecedario pittorico*, Venice, 1753;

Cochin C. N., *Voyage d'Italie*, Paris, III, 1758;

Zanetti M. A., *Della pittura veneziana*, Venice, 1771;

Lanzi L., *Storia pittorica della Italia*, Bassano, 1789;

Fiocco G., *Girolamo Forabosco ritrattista*, in "Belvedere", 1926; *La pittura veneziana del Seicento e Settecento*, Verona, 1929;

De Logu G., *Pittura veneziana dal secolo XIV al secolo XVIII*, Bergamo, 1958;

Zampetti P., in "La pittura del Seicento a Venezia", Exhibition catalogue, Venice, 1959;

Savini-Branca S., *Il collezionismo veneziano del Seicento*, Padua, 1964;

Pignatti T., *La Fraglia dei Pittori di Venezia*, in "Bollettino dei musei civici venezia, 1965;

Donzelli C.-Pilo G. M., *I Pittori del Seicento Veneto*, Florence, 1967 (with further bibliography).

FUMIANI GIANNANTONIO

Born at Venice in the year 1643 (or 1650 according to Arslan, 1946, p.44 after Orlandi), at an early age he went to Bologna and frequented the school of Domenico Ambrogi. On various canvases for the church of S.Lucia in that city, he served as Ambrogi's co-worker before returning to Venice where, in 1668, he painted an altar-piece for the church of S.Benedetto. Extant there now, it is of clear Caracci association.

In 1677, four mosaics for St. Mark's were completed to his cartoons. Thereafter he devoted himself mainly to the ceiling of the church of S.Pantalon in Venice, working from 1680 until it was finished in 1704. The whole church is full of his painting like an open book or rather an anthology of his activity.

Fumiani's large-scale undertaking undoubtedly ranks with the most impressive of seventeenth-century Venice; the artist resumes the tradition of the great masters of the sixteenth, in particular Veronese with touches out of Roman baroque.

These S.Pantalon canvases were "of pointless contrivance" to Longhi (1945, p.33) but very differently assessed by Arslan (1946, p.45). He also attributed the frescoes of Villa Contarini degli Scrigni (now della Rizza) at Mira by Venice to the same hand. "These frescoes painted probably about 1700 truly marked the halfway stage between Carpioni and Tiepolo"; thus Arslan, which is to put quite another complexion on his accomplishment in art.

Fumiani died on 8 April 1710, "at the age of sixty-seven or thereabouts", according to the entry in the register of the church of S.Pantalon in Venice where he was buried.

In his volume on Venetian painting (1771), Zanetti referred to Fumiani as distinct "from the host of other painters at the period in that line (perspective and architectural manner), and moreover in following the steps of a great master like Paolo Veronese . . ." With acumen, he went straight on to add that "there remained to be desired in his paintings only somewhat warmer colouring, more force and roundness, and more working of light and shade in the mass, to make the whole fully effective".

Lanzi was evidently following Zanetti when he wrote (1789): "More warmth of colouring and more balanced light and shade have been wished for from him; I would add more expression, which seems colder in attitude than usual with this school".

PRINCIPAL WORKS

 Mira (Venice), Villa Contarini degli Scrigni, *Tales from the Iliad and Aeneid;*
 Munich, Staatgemäldesammlungen, *Slaughter of the Innocents;*

Florence, Uffizi, *Punishment of Ananias;*

Padua, Duomo, *Circumcision; Rest on flight;*

Venice, S.Zaccaria, *Emperor Frederick II and Doge visiting S.Zaccaria monastery;*

S.Benedict, *Virgin and saints* (1668);

S.Pantalon, *Life of S.Pantaleone and triumph of Eucharist* (1684–1704);

Vicenza, S.Caterina, *Visit of S.Catherine;*

SS.Giacomo & Filippo, *Pentecost;*

Vienna, Academy, *Christ and the adulteress.*

ESSENTIAL BIBLIOGRAPHY

Zanetti A. M., *Descrizione di tutte le pubbliche pitture,* etc., Venice, 1733;

Orlandi P. A. (with additional material by Guarienti), *Abecedario pittorico,* Venice, 1753;

Zanetti A. M., *Della pittura veneziana,* Venice, 1771;

Lanzi L., *Storia pittorica della Italia,* Bassano, 1789;

Moschini G. A., *Guida per la città di Venezia all'amico delle belle arti,* Venice, 1803;

Lorenzetti G., *Venezia e il suo estuario,* 1926 (2nd ed. Rome, 1956);

Fiocco G., *La pittura veneziana del Seicento e del Settecento,* Verona, 1929;

De Logu G., *Pittura veneziana dal secolo XIV al secolo XVIII,* Bergamo, 1958;

Ivanoff N., *Le Sacre Reppresentazione di G. A. Fumiani,* in "Emporium", 1962.

Donzelli C.–Pilo G. M., *I pittori del Seicento veneto,* Florence, 1967 (with further bibliography).

GUERRI DIONISIO

He came from Verona and was born about 1620. In youth, he moved to Mantua and the chroniclers have it that he belonged to the school of Domenico Fetti. On returning to his native city, he soon earned a reputation but died in 1640, shortly after his twentieth birthday.

"By grace of this rare talent, when Verona was hoping to see painting restored to its first flower from decline, there were only tears to be shedding for his violent end in 1640 in the flower of his youth. From four of his works in the sacristy at S.Eufemia, how grave the loss sustained may be understood; in them, following on from Fetis his master of renown, it is plain he was taking a path that would have brought him to a truth of the highest order" (Zagata, 1749, p.216).

Local writers of the period concur to a man in praise of his gifts and grief for his untimely end, apparently as the result of violence. Cignaroli indicates the fact in a note to Dal Pozzo (1718): "He was . . . killed by wicked hand envious of his great talent, in the court of S.Nicolò. This much was told me by Bartolomeo Signorini the painter who got it from the Fontanas, the close relatives of the unfortunate dead man" (Zannandreis, 1891, p.260).

Zagata stated that apart from the four canvases at S.Eufemia, there were no other paintings of his in existence. Dal Pozzo however recorded two works—a "Woman of Samaria at the well" and a "Doubting Thomas"—in the sacristy of S.Nicolò. These were already gone by the time Zannandreis was writing. Orlandi—and the information is of distinct interest—averred that many works by Guerri were in private hands and subsequently sold and "taken out of Italy" where they

were going to pass as those of his master so well he knew how to imitate him" (Zannandreis). Lanzi also stressed the extremely close resemblance between Guerri's style and Fetti's way of painting. It is not without significance that among the works preserved of Dal Pozzo's collection, one was a "Jacob's dream", a subject that was dear to Fetti.

Guerri having been known and strongly admired in his life-time was subsequently quite forgotten. Acknowledgement is here made to Dr. Magagnato who brought the item illustrated to my notice and permitted its inclusion.

That Guerri trained within Fetti's sphere of influence is not in doubt. What may surprise is the facility with which he grasped the elements of greatest innovation in the Roman master, namely luminous chromatic treatment and free brushwork, and made them the basis of his own painting. Rubens' influence is not entirely ruled out, for he was at Mantua during the period.

PRINCIPAL WORKS

(Guerri's works—with the exception of *The Communion of S.Austin* in Verona civic museum—have been destroyed. They were once in the churches of S.Eufemia and S.Nicolò and palaces of Verona.)

ESSENTIAL BIBLIOGRAPHY

Dal Pozzo B., *Le Vite de' pittori . . . veronesi*, Verona, 1718;

Laceni G. B., *Ricreazione pittorica . . .*, Verona, I, 1720;

Orlandi P. A. (with additions by Guarienti), *Abecedario pittorico*, Venice, 1753;

Lanzi L., *Storia pittorica dell'Italia*, Bassano, 1789;

Zannandreis D., *Le Vite de' pittori, scultori e architetti veronesi*, Verona, 1891;

La Pittura del Seicento a Venezia (Exhibition catalogue), Venice, 1959;

Donzelli C.-Pilo G. M., *I Pittori del Seicento Veneto*, Florence, 1967.

HEINZ JOSEPH the younger

Born at Augsburg about 1600, he was taught painting by his father who was a painter also and engaged at the court of the emperor Rudolf II. The father is usually referred to as Heinz the elder to distinguish him from the son, both having the same Christian name.

He soon left Saxony, however, and went to live at Venice where he is known to have been by 1625 and where he remained until his death, subsequent to 1678.

According to Lanzi, at Venice he was "held in honour for small paintings of phantasies . . . For the most part, allegorical inventions complete with sphinxes, chimæras and monster grotesques; to be more precise, creations from the world of make-believe in that they derived from no classical example but were compounded of various members taken from different animals".

In addition, Boschini called him a "delightful painter". As Lanzi himself recorded, he had produced as an example of his manner of painting a figure of "Pallas routing a host of these phantasms by a building that is part destroyed and engulfed in smoke and flames; it represents Virtue overcoming the dark forms of Ignorance". There is an engraving of this piece in the "Carta del navegar pitoresco".

Painting of the sort seems to have been rewarding, for pope Urban VIII gave him a knighthood. However, contact with Venetian painting and the to-and-fro of artists in the city of the lagoons over the years tempered his native inclination; he paid heed to the tremendous teaching offered and assimilated it like the natural ecletic that he was.

He also painted religious pieces, examples remaining at S.Antonin & S.Fantin; others again were to be found at the church of SS.John & Paul where he worked long and intensively.

The Treviso altar-piece of 1642, in private hands, echoes abundantly the great sixteenth-century tradition of Venice though influence is discernible from painters on the move into Venice at the period. This extends to the point of pro-Caravaggio tinges and a quasi-classical approach preluding Carpioni (Zava Bocazzi F., 1959–60, p.207).

The Day of Judgment at S.Antonin (1661) reveals how far he adhered to late edition Caravaggio, then dominant at Venice, as taught by Langhetti, Zanchi and his fellow-countryman Carlo Lotb; there is evidence of Tintoretto's example as well. Yet his eye for detail that was real comes across alive and pungently.

This side of his personality may account for his liking for narrative painting. It may be seen in the important series of view-paintings of Venice of Palazzo Doria Pamphili, Rome. Four came to the Correr museum, Venice, as the gift of count Volpi di Misurata (1937).

Painted in 1648 they show Venetian scenes from the life or at least in line with calendar events: *Piazza San Marco; Redeemer Procession* on votive bridge across the Giudecca; *Bull-baiting in Campo S.Polo; Entry of the patriarch* Federico Correr to S.Pietro di Castello, then the cathedral church of Venice; *Gondola parade* at Murano.

His painting relied on allegorical or religious topics but it was the vignettes that captivated him, factual, in touch with what was going on in a real place, indeed a familiar one. The architecture assumes the role of a setting for the action, with tonal values of some liveliness, at times intensity. The narrating of episodes splits his concentration as he puts on record the living detail: personages or poor folk in salient poses.

His upbringing and the general taste for truth to be noted in painters of the northern school were contributory factors but this manner was undoubtedly influenced most by that in vogue among northern painters, in particular the Dutch with their long-standing love of such pieces. Mention may be made first and foremost in this context of the innovating genius of Peter Brueghel whose "Port of Naples" (Doria gallery, Rome) of 1553 gives I think the first fore-taste of view-painting marking the visit to Italy; it became the usual activity for Dutch painters working in Italy, plainly following on from a vernacular manner already explicit on home territory.

It is possible Heinz was at Rome. If this is so, then he might well have become familiar with painters whose interest lay in painting views. Alive in the sixteenth century, it became out of fashion when religious painting took to dreamscape settings. The fact that these works came from Rome could support the notion. Certainly, the view-paintings of Heinz are by way of being exceptional for the time, a point of departure for the rise to prominence in the eighteenth-century of Luca Carlevarijs and the other view-painters of Venice, though whether the influence was exerted direct or indirect is difficult to say.

PRINCIPAL WORKS

Modena, Este gallery, *Rialto bridge;*
Munich, Bayerisches staatsgemäldesammlungen, *Battle of blows* on S.Barnaba bridge;
Rome, Doria Pamphili gallery, *Piazza San Marco;*
Spilimbergo, cathedral, *Martyrdom of S.Andrew* (1665);
Venice, Correr museum, *Bull-baiting in Campo S.Polo; Gondola parade at Murano; Redeemer procession;*
S.Antonin, *Day of Judgement* (1661).

ESSENTIAL BIBLIOGRAPHY

Ridolfi C., *Le maraviglie dell'arte*, Venice, 1648;
Boschini M., *La carta del navegar pitoresco*, Venice, 1660;
Zanetti A. M., *Della pittura veneziana*, Venice, 1771;

36

Lanzi L., *Storia pittorica della Italia*, Bassano, 1789;

Fiocco G., *La pittura veneziana del Seicento e del Settecento*, Verona, 1929;

Lorenzetti G., *La pittura italiana del Settecento*, Novara, 1942;

Mariacher G., *H.J.* in "La Pittura del Seicento a Venezia", Exhibition catalogue, Venice, 1959;

De Logu G., *Pittura Veneziana dal secolo XIV al XVIII*;

Zava Boccazzi F., *Un inedito di Giuseppe Heinz il Giovane*, in "Arte Veneta", 1959–60;

Savini-Branca S., *Il collezionismo veneziano nel Seicento*, Padua, 1964;

Zampetti P., *J.H. il Giovane*, in "I Vedutisti Veneziani del Settecento", Venice, 1967.

LANGETTI GIOVANNI BATTISTA

Born at Genoa in 1635 (not 1625 as accepted following Soprani), his career began in his home city under the influence of painters at work there like Assereto and others. They inclined to the manner of Caravaggio, and to that of the Flemish school made known through the visits of Van Dyck and Rubens.

Subsequently, he went to Rome and joined the studio of Pietro da Cortona whose grandeur and monumental style is distinguishable in many of Langetti's canvases along with a decorative approach ever-present in his works.

Despite the relationship with Pietro da Cortona, he inclined more by nature to the naturalist manner after Caravaggio. In this artistic form which continued to suit him throughout his life, he was following the specific example of a Spanish-born painter trained in Naples, namely Ribera. The artist last-named made chiaroscuro contrast the hall-mark of his painting less for the sake of realism than as a means of conveying desperate and dramatic attitudes of mind through the intercourse of light and shadow.

Towards about 1660, the artist arrived at Venice and lived there for the remainder of his comparatively short life. He died there at the age of forty-one on 22 October 1666.

In the Lagoon area, the artist grew familiar with the great local tradition of painting and the work of Bernardo Strozzi, like himself from Genoa too, besides that of another Genoese, Cassano. Langetti's painting was thus endowed with a strengthened and heightened colour sensitivity; its expression remained, however, keyed to real subjects violent to the point of tragedy.

The activity in which he engaged at Venice was intensive; among his patrons he counted not only churches but members of noble families. For his manner was novel to the environment and aroused keen interest, as Boschini intimated. At Venice he may also have seen the early work of Luca Giordano, an artist compounding the neo-Caravaggio manner with the luminist approach. Lastly, the Venetian period is linked to two artists with whom he shared some affinity namely Antonio Zanchi from Este and Karl Loth, originally from Germany but long resident on Venetian shores.

Langetti's pet topics were drawn from the Bible and Roman history. He presented his sources not as narrative or by way of illustration but rather in the light of hard fact. His figures most times look like common or garden people, they are brawny and at times brash, their features very animated even when not actually aggressive.

As a result, Langetti loved dramatic subjects like S.Jerome penitent, or historical ones like the death of Archimedes or the martyrdom of saints.

Among his finest productions, reference may be made to the *Crucifixion* from the Teresian church, now on display at Ca' Rezzonico, Venice. The tonal values of the Christ imply intensely warm

colouring requirements whereas the anatomy is rendered with such sudden shifts of emphasis as to verge on violence. This painting may be said to sum up and celebrate Langetti's qualities. His presence in Venice was generally significant, in the context of a manner widely cultivated in the second half of the seventeenth century.

PRINCIPAL WORKS

Bologna, National art gallery, *Alexander and Diogenes;*
Brunswick, Landes museum, *Archimedes;*
Budapest, Fine arts museum, *Joseph interpreting the dreams in prison;*
Dresden, Gallery, *Apollo and Marsyas;*
Frankfurt-am-Main, Städelsches kunstinstitut, *Cain fleeing after the death of Abel;*
Genoa, Palazzo Bianco, *Mercury and Argus;*
Leningrad, Hermitage, *Samson and Delilah;*
Milan, Sforza castle, *Caesar with the head of Pompey;*
Pommerfelden, Schönborn coll., *Patience of Job; Joseph interpreting dreams;*
Warsaw, National museum, *Susanna and the elders;*
Venice, ex-Teresian church, *Christ and the Magdalen;*
 S.Marziale church, *Crucifixion;*
 Querini Stampalia foundation, *Alexander and Diogenes;*
 SS.Giovanni & Paolo church, *Samson;*
 Priv. coll., *Death of Archimedes.*

ESSENTIAL BIBLIOGRAPHY

Boschini M., *La carta del navegar pitoresco*, Venice, 1660; *Le ricche minere della pittura veneziana*, Venice, 1674;
Soprani R., *Le vite de' pittori . . . genovesi*, Genoa, 1674;
Zanetti A. M., *Descrizione di tutte le pubbliche pitture . . . di Venezia*, Venice, 1733;
Soprani R.-Ratti C. G., *Le vite . . .*, Genoa, 1768;
Zanetti A. M., *Della pittura veneziana*, Venice, 1771;
Lanzi L., *Storia pittorica della Italia*, Bassano, 1789;
Alizeri F., *Guida artistica per la città di Genova*, Genoa, 1847;
Fiocco G., *G. B. Langetti e il naturalismo a Venezia*, in "Dedalo", 1922-3;
Lorenzetti G., *Venezia e il suo Estuario*, Milan, 1926; 2nd ed., Rome, 1956;
Fiocco G., *La pittura veneziana del Seicento e Settecento*, Verona, 1929;
Pallucchini R., *L'ultima opere di G. B. Langetti*, in "Bollettino d'Arte", 1934;
Arslan W., *Il concerto di luminismo e la pittura veneta barocca*, Milan, 1946;
Morassi A., *Exhibition of Seicento and Settecento painting in Liguria*, Milan, 1947;
Longhi R., *Un ignoto corrispondente del Lanzi sulla Galleria di Pommersfelden*, in "Proporzioni", III, 1950;
Ivanoff N., *Intorno al Langetti*, in "Bollettino d'Arte", 1953;
De Logu G., *Pittura veneziana dal XIV al XVIII secolo*, Bergamo, 1958;
Mariacher G., *Giambattista Langetti*, in "La Pittura del Seicento a Venezia", Exhibition catalogue, Venice, 1959;
Donzelli C.-Pilo G. M., *I Pittori del Seicento Veneto* (with further bibliography), Florence, 1967.

38

LAZZARINI GREGORIO

Born at Venice in 1665, he was a pupil first of Francesco Rosa, then Gerolamo Forabosco and finally came within the sphere of influence of Pietro della Vecchia. His artistic reputation grew as time passed, no doubt in part due to the studio he opened near S.Pietro di Castello, which was highly popular. Among his students were Antonio Bellucci and Tiepolo whose first lessons in the art were given him by Lazzarini.

His speciality was rendering colour imbued with light and in this regard he stood apart from the last of the "tenebrosi", the line of painters whose chiaroscuro emphases dominated Venetian art in the second half of the seventeenth century. His colour treatment, so receptive to the quality of light, was probably drawn from the work of Forabosco while the vivid neo-classical overtones echo that of Padovanino.

His long life was spent at Venice, where he would have had opportunity to study the work of Luca Giordano in addition and this may have helped in fusing and dispersing his colour material still further. From this point of view, he may be deemed a reviver of the Venetian tradition towards the close of the seventeenth century.

With Bellucci, he frescoed Palazzo "Morolin" on the Grand canal, Venice, built by Sebastiano Mazzoni for Pietro Liberi. He was a prolific painter, frescoing many palaces in Venice itself and villas out in the Veneto. Commissions came from beyond the frontiers of Italy, for instance from the counts of Schonborn and princes of Liechtenstein. Lazzarini also undertook work for the doge's palace where in 1694 he decorated the triumphal arch in Sala dello scrutinio, in honour of Francesco Morosini. The work is significant, shewing some allegiance to the manner of Balestra; its indications of a classical approach were to have effect in the eighteenth century.

His chief claim to fame, however, lies beyond all shadow of doubt in having had Giambattista Tiepolo for a pupil, although after this early start Tiepolo in fact drew away from Lazzarini in favour of Piazzetta. Other students include Gaspare Diziani and Giuseppe Camerata.

PRINCIPAL WORKS

> Bergamo, Carrara gallery, *Portrait of a man;*
> Hampton court, Royal collections, *Cupid and Psyche;*
> London, National gallery, *Portrait of Antonio Correr* (1685);
> Macerata, Palazzo Bonacossi, *Death of Dido* (1712);
> Pommersfelden, Schonborn coll., *Hercules and Omphale;*
> Rovigo, Accademia dei concordi, *Christ and the women of Samaria at the well;*
> Venice, S.Clemente, *Adoration of the Magi;*
>> S.Pietro di Castello, *S.Lorenzo Giustinian almsgiving* (1691);
>> Chiesa dell'Ospedaletto, *Pool of Bethesda;*
>> S.Stae, *S.Paul transported to heaven;*
>> S.Pantalon, *S.Pantaleone healing the sick;*
>> Chiesa della Salute, *Elijah and the angel;*
>> Correr museum (Ca' Rezzonico), *Rebecca and Eleazar;* etc.

ESSENTIAL BIBLIOGRAPHY

> Zanetti A. M., *Descrizione di tutte le pubbliche pitture,* etc., Venice, 1733;
>> *Della pittura veneziana,* Venice, 1771;
> Lanzi L., *Storia pittorica della Italia,* Bassano, 1789;
> Moschini G. A., *Guida di Murano,* Venice, 1808;
> Da Canal V., *Vita di Gregorio Lazzarini,* Venice 1809;

39

Fiocco G., *La pittura veneziana del Seicento e del Settecento*, Verona, 1929;

De Logu G., *Pittori veneti minori del Settecento*, Venice, 1930;

Lorenzetti G., *Venezia e il suo Estuario*, ed. 1956;

Donzelli C., *I Pittori Veneti del Settecento*, Florence, 1957;

Pilo G. M., in "La Pittura del Seicento a Venezia", Exhibition catalogue, Venice, 1959;

Martini E., *La Pittura Veneziana del Settecento*, Venice, 1964;

Pignatti T., *La Fraglia dei pittori di Venezia*, in "Bollettino dei Musei Civici Veneziani", 1965;

Donzelli C.–Pilo G. M., *I Pittori del Seicento Veneto*, Florence, 1967.

LIBERI PIETRO

Born at Padua in the year 1614, he transferred to Venice in 1643. His life was an adventurous, episodic one. In youth, he did a good deal of travelling, first along the shores of the Mediterranean —the Middle east, to Portugal and Tunisia. He had also been to Hungary, France and Spain. The upshot of this was first-hand knowledge of an extraordinary range of artistic currents. Further, the poise and confidence he also acquired in the process characterised him all his life.

At the start there was undoubtedly a close tie with Padovanino, then De Boni, borne out by affinities of manner in the early productions. Curiosity would not let him rest, however, his love of travel being one outlet. In studying the works of the past, he found a point of focus for his admiration in Titian who seems to have remained a constant influence throughout his career.

Between 1638 and 1641, he was at Rome. Boschini noted how he wanted to see everything— whether classical antiquities or splendours of Renaissance art from Raphael to Giulio Romano. Next, he encountered prime examples of baroque, especially frescoes of Pietro da Cortona and probably those by Annibale Caracci at Palazzo Farnese.

He visited Siena, Florence and Parma among other places. As a result, the knowledge and experience that went into his work when he reached Venice in 1643 made him an exponent, if not the leading exponent of the academic movement of the seventeenth century. Venice was in the throes of an artistic crisis, unresolved despite the efforts of Strozzi, Saraceni and other painters. In these circumstances, his classical approach aroused deep admiration and all the work he could wish for. Some of his best-known pictures belong to this period: the *Altar-piece* of SS.John & Paul; that of *S.Antonio* in the Chiesa della Salute. From 1656 to 1658, he was engaged on the vast canvas for the ducal palace commemorating the *Victory of the Dardanelles*.

An invitation to Vienna followed; he arrived in 1658 and was made count palatine. From Vienna he ranged still further afield through Germany and Bohemia, the notables everywhere clamouring for his services, preferably in the sense of the mythological and historical pieces he assiduously produced.

In late 1659 returning to Venice, he painted the *Bronze serpent* for S.Pietro, then the cathedral church.

After that he was at Bergamo and depicted the *Great flood* for S.Maria Maggiore. In 1665 at Padua, he adored the sacristy ceiling of S.Antonio with an *Allegory* treating of the saint in glory. During the last period, he was influenced by Sebastiano Mazzoni and also Luca Giordano who undoubtedly helped render his paint material more luminous and richly-bodied.

His reputation reached such a pitch he was wealthy enough to have a palace built for himself on the Grand canal in 1671; it still stands on Volta de' Canal facing Ca' Foscari. Mazzoni was his architect. He had connections with Lazzarini too, in his old age, and certainly influenced in turn Bellucci and Vincenzo Pagani to an appreciable degree.

In his day he was celebrated but tastes change and he fell from favour. His re-appraisal as an artist dates from quite recently. Of course his style is often fairly superficial, the use of traditional rules and patterns all too apparent and stemming in particular from Titian. Having said that, it must be conceded that he did cause a ripple in Venetian waters when nothing else new was stirring. His brush-work is so light and lively it affords the clearest evidence of his endeavours to achieve something different in painting, especially is this so during the closing stages, perhaps attributable to the effect on him of the brilliant Sebastiano Mazzoni.

Zanetti praised his "skill and dispatch", likewise his "admirable grace and felicity". More recently, Longhi (1946) found fault with him on a score of over-facility as an unabashed imitator of the school of the sixteenth century. Other experts, however, like Ivanoff and Arslan have taken a different view and see him in the context of the classical manner, foreshadowing to some extent the triumphs that Venetian art was to achieve towards the close of the century.

Pietro Liberi died at Venice in 1687. He had a son by name Marco who had helped him and then continued painting after his death. Certain attributions to him are few, owing to the risk of confusing him and his father. He has been a subject of some study in very recent years. One documented item, *S.Cecilia and angel at organ*, shows distinct detachment from fatherly influence. The painting itself is firmer and more compact than the loose brush-work that is typical of Piero. Marco seems essentially nearer Bellucci, with rather over-precise treatment of form and effects of light that create a lyrical and contemplative feeling of mood. The dates of his birth and death are lacking, though he would have been alive after 1696 when he painted the *Tiburtine sibyl* at Vicenza.

PRINCIPAL WORKS

Berlin, Staatliche museen, *Diana & Acteon;*
Florence, S.Filippo Neri, *Oratory ceiling* (frescoes);
Modena, Galleria estense, *Birth of John baptist;*
 S.Pietro, *Holy family with angels;*
Munich, Bayerisches staatsgemsallungen, *The toilette;*
Montagnana, S.Francesco, *S.Anthony with angels;*
Kassel, Museum, *Susanna bathing; Bathsheba bathing;*
Padua, S.Francesco, *Franciscan saints;*
 S.Giustina, *Ecstasy of S.Gertrude;*
 S.Luca, *Nativity;*
 Civic museum, *Self-portrait;*
Rovigo, Rotonda, *Allegory of Alvise Foscarini;*
Schleissheim, Bayerisches staatsgesammlungen, *Medoro & Angelica;*
Venice, Chiesa dei Carmini, *Virgin giving habit to S.Simon Stock;*
 Chiesa della Salute, *Annunciation;*
Vercelli, Gorgogna museum, *Sleeping Venus;*
Vicenza, Duomo, *Sacrificial offering of Noah.*

ESSENTIAL BIBLIOGRAPHY

Ridolfi C., *Le maraviglie dell'arte*, Venice, 1648;
Boschini M., *La carta del navegar pitoresco*, Venice, 1660; *Le ricche minere della pittura veneziana*, Venice, 1674;
Zanetti A. M., *Della pittura veneziana*, Venice, 1771;
Lanzi L., *Storia pittorica dell'Italia*, Bassano, 1789;
Fiocco G., *La pittura veneziana del Seicento e Settecento*, Verona, 1929;
Longhi R., *Viatico per cinque secoli di pittura veneziana*, Florence, 1946;

Arslan W., *Il concetto di luminismo nella pittura veneto barocca*, Milan, 1946;

Ivanoff N., *Gli affreschi del Liberi e del Celesti nella villa Rinaldi Barbini di Asolo*, in "Arte Veneta", 1949;

Pilo, G. M., in "*le pittura del Seicento e Venezia*" catalogo delle mostra, Ce Pesero, Venezia 1959;

Chiappini di Sorio G., *L'inventorio delle casie di P. Liberi* in "Arte Veneta" 1964;

Donzelli C.-Pilo G. M., *I pittori del Seicento veneto*, Florence, 1967 (with good bibliography to that date).

LOTH JOHANN KARL

Born at Munich in 1632, he learnt about painting from his father, Ulrich by name. He, in turn, had studied under Saraceni and thus practised the pro-Caravaggio manner. At first, the son worked in Germany, at Vienna and then moved to Florence, Milan and Verona, finally becoming resident at Venice. His name was entered on the guild register of painters from 1687, and in Venice he remained for the rest of his life, that is until 1698.

Before becoming resident, he had been on a visit in 1660 and was acquainted with local trends. Some have called him a pupil of Pietro Liberi; in truth, his manner of working is akin to that of Langetti and the natural painters of remote Caravaggio extraction. Together with Zanchi and more especially Langetti, he belonged to the stream known as the Tenebrosi, from their love of extremes in colour arrangement. With Loth, this meant a matching choice of themes, strong often to the point of violence.

After the death of Langetti in 1676, there was less expressionist upsurge in Loth's work and more a style of painting in line with emotive content on occasion of unfeignedly languid form. The chromatic style became lighter-bodied, the treatment livelier.

In late works, the artist seems to draw on the baroque manner of Pietro da Cortona, as in the *Rebecca at the well* of San Francisco museum. The *S. Joseph altar-piece* (1681) in S. Silvestro, Venice, achieves a manner completely fluid in terms of composition and a quality of light little short of festive, seeming to echo the teaching of Liberi and also that of Gaulli.

Loth's contribution was notable in respect of Venetian painting, also in the spread of a revivalist manner which embraced tenets of Roman figurative art and broadened north in the direction of Bavaria and Austria.

PRINCIPAL WORKS

Bassano, Civic museum, *Samson and Delilah;*
Berlin, Staatlisches museen, *Apollo and Marsyas;*
Brescia, Civic art gallery, *Samson and Delilah;*
Dresden, Gemälde galerie, *Shunning of Job;*
Genoa, Royal palace, *Caritas;*
Kassel, Staatlisches gemäldegalerie, *Prodigal son's return;*
Leningrad, Hermitage, *Rebecca at the well;*
London, National gallery, *Mercury and Argus;*
Munich, Theatine church, *Death of S. Andrea Avellino;*
 S. Pietro, *Martyrdom of S. Erasmo;*
 Bayerisches staatsgmslgn.; *Crown of thorns; Self-portrait; Death of Seneca;*
Pommersfelden, Schönnborn coll., *Cornelia and the Gracchi;*

Trent, Duomo, *Nativity;*

Venice, S.Silvestro, *S.Joseph, child Jesus and glory of Mary* (1681);

Ospedaletto church, *The dead Christ with SS.Bartholomew and Catherine;*

Vienna, Kunsthistorisches museum, *Jacob blessing Joseph's sons.*

ESSENTIAL BIBLIOGRAPHY

Ridolfi C., *Le maraviglie dell'arte*, Venice, 1648;

Boschini M., *La carta del navegar pitoresco*, Venice, 1660; *Le ricche minere della pittura veneziana*, Venice, 1674;

Zanetti A. M., *Della pittura veneziana*, Venice, 1771;

Arslan E., *Il concetto di luminismo e la pittura veneto barocca*, Milan, 1946;

Lorenzetti G., *Venezia e il suo estuario*, Rome, ed. 1956 (1st ed. 1926);

Ewald G., *Johann Karl Loth*, Amsterdam, 1965 (with good bibliography);

Donzelli G.–Pilo G. M., *I pittori del seicento veneto*, Florence, 1967.

MAFFEI FRANCESCO

The date of his birth, at Vicenza, remains unknown but belongs to about 1600. He trained in his native city under Alessandro Maganza, a mannerist painter of note. The paramount influence with him was, however, that of the great sixteenth-century tradition of art, from Veronese, Bassano and perhaps including El Greco.

The first signed work goes back to 1626, and to the oratory of S.Nicola da Tolentino in Vicenza. Twelve years passed and he was at Venice where, according to Boschini, he completed two paintings, one for the Incurables church and the other for the Tolentine church, both left unfinished by Sante Peranda on his death in 1638.

Zanetti, perhaps going on from this information, deems Maffei an actual pupil of Peranda though this is not borne out by the facts. At the date, his training was behind him and some years experience too. Not that he stayed long at Venice but was soon off working at Vicenza, Brescia, Rovigo and then, in 1657, at Padua where he died in 1660.

Maffei is the first great figure of Venetian art in the seventeenth century to become the subject of modern critical appraisal. His personality is a puzzling one and has led to investigation of a whole forgotten rather than undervalued cultural situation.

Fiocco set the pace with a fundamental contribution (1924). This in turn followed on the Exhibition so fraught with surprises, devoted to artists of the seventeenth and eighteenth centuries and held at Palazzo Pitti in 1922. After work by Ivanoff (1942), there was the special exhibition at Vicenza in 1956. Maffei became a topic of general interest and now appears as one of the animating spirits of Veneto art in the seventeenth century.

He has his own kind of hankering after the past. Somersaulting Caravaggio and all his effects, though he can hardly have been less than cognisant of him, whether or not by an intermediary, he harks back to the great and glorious tradition of the Venetian sixteenth century and there finds the living substance giving power to his own works.

It would be far from correct to call him a late mannerist painter. He had travelled beyond both naturalism of form and mannerism. He presents a new edition, after much thought, and holds a key to future progress. The first half of the century failed to produce a coherent pattern of development but new triumphs were to derive out of the great sixteenth-century tradition, as Fetti and Strozzi were attempting to prove in formal matters. The dialogue was re-opened, after a temporary break-down inevitable in the circumstances.

His paint material is diffuse and applied rather nervily, the composition audacious sometimes to the point of imbalance, the brushstrokes intrepid, the tonal values cover an incredible range from dull to dashing, light to dead-weight. The result is that he cuts a typically baroque figure: the world is a restless place (rather than weird), never still and very complicated where each and every one labours in his own style after his own inner being, despite the levelling culture which was one of the period's main features. His contemporary fellow-citizen by choice—Giulio Carpioni—is a case in point, different, almost diametrically so.

The 1956 exhibition went some way to clearing up the problems of his stylistic development. Some difficulties remain but it has to be admitted that a unified and entirely untarnished thread is traceable the length of Maffei's career. His evolution is slow; it is enriched by re-thinking and by recollection. Every time he turns to sixteenth-century art, when all is said and done he produces a cluster of original notions. Precedents out of Veronese come across with a typically baroque look, tumultuous and stark, flat and yet shot with sudden high-lights that go straight back to Tintoretto. In his prime, the chromatic tension of Maffei is slightly muted in favour of more composed and balanced treatment of form. This may be seen in his Padua works from 1657 onwards. The colour range becomes lighter-bodied though there is the occasional dramatic twist, part and parcel of his strange contorted personality, impulsive, generous and aggressive. His painting is as astonishing as it is evocative, and was found stimulating to other painters at work in Venice towards the end of the century, perhaps including Tiepolo on the threshold of his career.

PRINCIPAL WORKS

> Arzignano (Vicenza), Parish church, *Visitation;*
> Brescia, Duomo vecchio, *Procession;*
> Feltre, Duomo, *Virgin and child with Infant baptist;*
> Modena, Este gallery, *Adoration of the shepherds;*
> Oxford, Ashmolean museum, *Adoration of the shepherds;*
> Padua, S.Tomaso Cantauriense, *Adoration of the Magi; Agony in the garden; Crucifixion;*
> > Oratorio delle zitelle, *Scenes from the life of the Virgin;*
> > Civic museum, *Allegory of the podesta Girolamo Priuli; Allegory of the inquisitor Alvise Foscarini,* etc.;
> Pesaro, Civic museums, *Conversion of S.Paul;*
> Rovigo, S.Maria della Rotonda, *Presentation in the temple; Coronation of the Virgin;*
> Trent, Buonconsiglio castle, *Jephthah's daughter; Esther and Assuerus; Solomon and the queen of Sheba;*
> Venice, Accademia gallery, *Virgin appearing to S.Filippo Neri;*
> > Querini Stampalia foundation, *Milo of Crotone;*
> > Priv. coll., *S.George;*
> > Count Lodovico Foscari coll., *Cain and Abel; Sacrifice of Melchizedek;*
> > SS.Apostoli church, *Tobias and the angels;*
> Vicenza, Civic museum (E.C.A. deposit), *Rest on flight;*
> > Duomo, *Baptism of Christ, Life of S.Joseph.*

ESSENTIAL BIBLIOGRAPHY

> Ridolfi C., *Le meraviglie dell'arte,* Venice, 1648;
> Boschini M., *La carta del, navegar pitoresco,* Venice, 1660; *Le ricche minere della pittura veneziana,* Venice, 1674;

Zanetti A. M., *Descrizione di tutte le pubbliche pitture della città di Venezia*, Venice, 1733;

Cochin C. N., *Voyage d'Italie*, Paris, 1758;

Zanetti A. M., *Della pittura veneziana*, Venice, 1771;

Lanzi L., *Storia pittorica della Italia*, Bassano, 1789;

Fiocco G., *Francesco Maffei*, in "Dedalo", 1924; *La pittura veneziana del Seicento e del Settecento*, Verona, 1929;

Ivanoff N., *Aggiunte su Francesco Maffei*, in "Rivista d'Arte", 1936;

Morassi A., *Catalogo delle cose d'arte . . . di Brescia*, Rome, 1939;

Ivanoff N., *Francesco Maffei*, Padua, 1942;

Arslan W., *Il concetto di luminismo e la pittura veneta barocca*, Venice, 1946;

Zampetti P., Muraro M., *Aggiunte al catalogo del Maffei* in "Emporium", 1948;

Barbini-Cevese-Magagnato, *Guida di Vicenza*, Vinceza, 1953;

Arslan W., *Catalogo delle cose d'arte di Vicenza, le chiese*, Rome, 1956;

Ivanoff N., *Catalogo della mostra di F. Maffei* (with bibliography), Venice, 1956;

De Logu G., *Pittura veneziana dal XIV al XVIII secolo*, Bergamo, 1958;

Zampetti P., *F. Maffei* in "Catalogo della pittura del Seicento a Venezia", Venice, 1959;

Donzelli C.-Pilo G. M., *I Pittori del Seicento Veneto*, Florence, 1967 (with further bibliography).

MANAIGO SILVESTRO

Born at Venice in 1670, he came of a family from the Friuli. A pupil of Gregorio Lazzarini, together with Gianbattista Tiepolo, he shews close association with his master's approach and methods unlike his brilliant fellow-student who soon determined on a different path.

He maintained a rather conventional attitude to his art, correct in matters of form but unendowed with striking originality. Pallucchini nevertheless found his *Martyrdom of S.James archdeacon*, painted between 1743 and 1744 for the Duomo di Bergamo, contained an "unprecedented accentual liveliness with its dynamic composition and emboldened chiaroscuro" (1960). It is evident that Manaigo was also influenced at the period by the manner of Piazzetta.

The artist was entered on the guild register from 1687 to 1734; he died after the work done at Bergamo, that is after 1744. Zanetti (1733) mentioned works by him in the church of S.Maria dei Servi (now lost, the church demolished), but had no great regard for his talents as productive more of "trappings than true greatness".

PRINCIPAL WORKS

Bergamo, Duomo, *Martyrdom of S.James archdeacon;*

Brescia, Palazzo Barbisoni, *Saul* (?);

Palazzo Gaifani, *Passing of S.Joseph* (?);

Venice, S.Stae, *S.Peter and angel.*

ESSENTIAL BIBLIOGRAPHY

Chizzola L., *Le pitture di Brescia*, Brescia, 1760;

Zanetti A. M., *Della pittura veneziana*, Venice, 1771;

Lanzi L., *Storia pittura della Italia*, Bassano, 1789;

Lorenzetti G., *Venezia ed il suo estuario*, Milan, 1926 (2nd ed., Rome, 1956);

Donzelli C., *I pittori veneti del Settecento*, Florence, 1957;

Pallucchini R., *La pittura veneziana del Settecento*, Venice-Rome, 1960.

MATTEO DE' PITOCCHI

This painter was born probably at Padua about the year 1626. He got the name De' Pitocchi (of the underprivileged classes) since according to Brandolese (1795) "they were just the sort of people he liked painting which he did with some charm. He lived for a long while at Padua and there he died".

As a result of recent work (1964 by Sartori; 1966 by Bortolini), his real name has come to light as Matteo Ghidoni. That he learnt a great deal from the engravings of Callot is plain; the fact was that he liked doing scenes of popular life and achieved a naturalness of rendering that does not exclude considerable artistic sensitivity.

He was in addition a painter of sacred pieces. He worked for S.Antonio in Padua over a documented period 1652-7. From 1684 to 1685 he was engaged in painting the *Albero francescano* for the same church, now in the attached conventual building. It needs saying that his approach to art must not be confused with the near-violent realist outlook typical for example of a Bellotto. On the contrary, he goes in for soft impasto to a degree that might support the argument he was acquainted with Monsù Bernardo, at Venice from 1651 to 1654.

PRINCIPAL WORKS

Padua, Sala delle studio teologico del Santo, *Albero francescano;*
S.Maria dei Servi, *Birth of Christ; Madonna saving a condemned man from torture on the wheel;*
Civic museum, *Country-dance;*
Rovigo, Accademia dei Concordi, *At the hostelry;*
Venice, Querini Stampalia foundation, *Country feast; Country people quarrelling.*

ESSENTIAL BIBLIOGRAPHY

Lanzi L., *Storia pittorica della Italia*, Bassano, 1789;
De Logu G., *Pittori veneti minori del Settecento*, Venice, 1930;
Bortolini G., *Precisazioni archivistiche sul pittore Matteo Ghidoni detto de' Pitocchi* in "Arte Veneta", 1966;
Donzelli C.-Pilo G. M., *I pittori del Seicento veneto*, Florence, 1967.

MAZZONI SEBASTIANO

Born at Florence in about 1611, he was a pupil of Cristoforo Allori according to Temanza. His nature was such, however, that he could bear no restraint even as a youth and was soon casting wider in search of inspiration.

Ivanoff has indicated and it may well be so, that he learnt something from the scenes of common life being painted by his fellow-citizen, Giovanni da S.Giovanni. There was the work of Furini also and other painters, for the art world in Tuscany during the first half of the century presented a thriving picture.

Again, following Temenza, he left Florence, indeed fled away on account of some "stinging" verses he had penned and thus brought down enmity on his own head. Why Venice became his haven is not known but Ivanoff suggests it could have been friendship with Pietro Liberi who was in Tuscany about 1640. It was a major decision once made since he remained there for the rest of

his life. All the same he found cause to complain of the Venetian environment and expressed a wish to leave in a sonnet which reveals a good deal of the man behind the paintings.

Though a precise date for his arrival at Venice cannot be given, it was not after 1648. In that year he produced the first of two altar-pieces for the church of S.Benedetto. At Venice he certainly came into contact with the art of Strozzi during his early days there but was soon of sufficient cultural experience for his work to bear a stamp unmistakably individual. No one in that complexity of intermingling currents, namely the Venetian art world of the second half of the century, forms quite such an island apart as Mazzoni.

Nineteenth-century writers make no mention of him. It was not until 1928 that he became a subject of attention after Fiocco's brief but brilliant study of him had distilled the essential qualities of Mazzoni's art. Subsequently, Gnudi (1935) added a further dimension by treating of his influence in training Crespi. Studies by Ivanoff (1947 et seq.), Gioseffi (1954) and Valcanover have further increased his standing. His hermetic figure has gradually become more plain although the last word has still to be written about this striking but proud and prickly character. His verse is no vapid affectation but significant of a rather extravagant many-faceted nature.

"Grotesque" is a word often used to describe the art of Mazzoni. It looks as if "most dramatic" then at work would be more appropriate, his painting only serving to convey some measure of high spirits. As painting goes, it is neither restful or complacent, not literature and not hack either. His art is full of implicit movement, new ideas, daring structures, unexpectedly inventive touches, in a phrase it is full of giving, forward-looking and the outcome of his creative impulse. In the second half of the seventeenth century the position he occupies is a lonely one and on this account has not been understood. Getting to grips with the sources of influence as the period becomes known in depth, what emerges is that the new factor on the scene and not only at Venice was none other than himself.

The dates concerning him are few. The two S.Benedetto pieces belong to 1648–9; *Banquet of Cleopatra* (1660) a marvel of a painting in Washington, for envisaging what the eighteenth-century is going to yield in the annals of Venetian art. Another work, a canvas in the Carmelite church at Venice, is of 1669. To these must be added his literary productions: "Il tempo perduto" (Time lost) of 1661; "Il buon viaggio scherzoso" (The merry journey) and "La pittura guerriera" (War painting) are both of 1665.

An architect besides poet and painter, he was responsible for Pietro Liberi's house on the Grand canal; a controversial figure, freedom-loving, never still, there is plenty of scope for further investigation of his life and work. To consider his career as a painter of genius and passion producing new solutions after long re-thinking and moving from the substantial textured early works to the ethereal and elusive visionary quality of the *Apollo and Daphne* at Ravenna, means gaining some insight into how far he travelled the hard road to greatness.

He died all but forgotten on 22 April 1678. According to the chronicler, "The chevalier Sebastiano Mazzoni aged 67 fell down a staircase yesterday at his excellency Zan Battista Donà's and sustained a broken head of which he died at nones this morning". How grim indeed to "climb up and down other people's stairways"; the poet Dante spoke figuratively, exiled from Florence like the poor old painter who thus literally lived the words.

Sebastiano Mazzoni began to paint in the late Tuscan mannerist idiom. His aim was free creativity, a sustained dramatic expression matching a deepening awareness of priorities which could only grow from a wide spectrum of experience. His ambitions in the direction of rendering light remove him from the contemporary context, foreshadowing future developments; the same holds true of his whirling brush-work which has the urgency of drawing and its lack of textural depth, and represents an immediate response of hand to mind.

Florence, Gondi coll., *Venus and Mars;*

Milan, Priv. coll., *Erection of the cross;*

Munich, Alte pinakothek, *Death of Cleopatra;*

New York, Kress coll., *Jephthah's sacrifice;*

Padua, Civic museum, *Portrait of a warrior;*

Ravenna, Civic museum, *Apollo and Daphne;*

Rome, Briganti coll., *Charity;*

Rovigo, Accademia dei Concordi, *Death of Cleopatra;*

Trieste, Museo civico sartorio, *Sacrifice of Isaac;*

Venice, S.Benedetto, *S.Benedetto commending the parish priest to the Virgin; S.Benedetto in glory;*
Cini foundation, *Annunciation;*

Washington, National gallery, Smithsonian institution, *Cleopatra's feast.*

ESSENTIAL BIBLIOGRAPHY

Mazzoni S., *Il tempo perduto; scherzi sconcertanti di Sebastiano Mazzoni, pittore,* Venice, 1661;

Boschini M., *Le minere della pittura,* Venice, 1664;

Mazzoni S., *La pittura guerriera,* Venice, 1665; *Il buon viaggio scherzoso,* Venice, 1665;

Boschini M., *Le ricche minere della pittura veneziana,* Venice, 1674;

Zanetti A. M., *Descrizione di tutte le pubbliche pitture di Venezia,* Venice, 1733;

Temanza T., *Zibaldon di memorie storiche,* etc., 1738, ms Cod n.CCCLXI, M.M.3, Biblioteca Seminario Patriarcale;

Zanetti A. M., *Della pittura veneziana,* Venice, 1771;

Lanzi L., *Storia pittorica della Italia,* Bassano, 1789;

Fiocco G., *Sebastiano Mazzoni,* in "Dedalo", 1928-9; *La Pittura Veneziana del Seicento e del Settecento,* Verona, 1929;

Gnudi C., *Sebastiano Mazzoni e le origini del Crespi,* in "Comune di Bologna", 1935; *Giunte al Mazzoni,* in "Critica d'Arte", 1935-6;

Ivanoff N., *Un contributo a Sebastiano Mazzoni* in "Arte Veneta", 1947; *Ignote opere di Sebastiano Mazzoni* in "Emporium", 1948;

Voss H., *Pietro Ricchi* in "Arte Veneta", 1951;

Ivanoff N., *Disegni di Sebastiano Mazzoni* in "Commentari", 1953; *Esordi di Sebastiano Mazzoni* in "Emporium", 1957;

De Logu G., *Pittura Veneziana dal secolo XIV al secolo XVIII,* Bergamo, 1958;

Ivanoff N., *Sebastiano Mazzoni* in "Saggie e memorie di Storia dell'arte", 1959;

Zampetti P., *Sebastiano Mazzoni* in "La Pittura del Seicento a Venezia", Exhibition catalogue, Venice, 1959;

Donzelli C.-Pilo G. M., *I Pittori del Seicento Veneto,* Florence, 1967 (with further bibliography).

MOLINARI ANTONIO

Born at Venice in 1665, he was the son of a painter by name of Giambattista who was a former pupil of Pietro della Vecchia. His own master was Antonio Zanchi, one of the artists connected with the "Tenebrosi" stream. His career covered a difficult period in Venetian painting when the tradition of the seventeenth century was still a primary but rather stutifying influence.

His inclination drew him to painting in a vein spacious and light, his brush-work flowing competently with plenty of high-lights. Zanetti wrote of him in the eighteenth century, that "his robust individual genius saved him from Zanchi's dark school and by concepts noble as they were delightful made his style rewarding".

The facts about him are on the slender side. He was entered on the guild register of Venetian painters in 1701 and so continued until 1735. The exact year of his death is unknown. But the evidence shews that Molinari, like other contemporary artists, was affected by the teaching of Luca Giordano and this may account for his growing appreciation of light. On the other hand, there is undoubted influence from Liss.

A very cultivated painter, stylistic divergencies often occur in the course of his work, as commonly happens when the manner of civilisation has reached a turning-point between one style and the next. Lanzi noted his limitations with commendable insight, as follows. "He emerged from the school of Zanchi and promptly set about unlearning most of what he had been taught. His style was uneven from work to work, as is only to be expected when a man wants to leave the beaten track for a new road and cannot quite make it. At his best, it satisfies the eye; there is care in design and execution, the forms are fine, the habiliments richly textured, the tints well-considered and consonant".

In works on the grander scale, Molinari relied to a fair extent on academic devices. This is especially discernible in the elaborate *Feeding of the five thousand* of S.Pantalon church at Venice. Modern critical opinion has grown increasingly emphatic on the topic of his importance for the development of Venetian painting in the eighteenth century, with particular reference to Piazzatta whose first teacher Molinari was.

He painted a *Visitation* for the church of S.Zaccaria which has served as text for the modern upholders of a strong tie between the two artists. It is worth bearing in mind that this may quite well have worked both ways, the pupil in turn affecting his master.

It will, however, be generally agreed that there can be no proper evaluation of Molinari's efforts until his canvases—a goodly number of which are in Venetian churches—have been freed of the accumulations of dust and dirt covering them, no doubt to the detriment of their chromatic values.

PRINCIPAL WORKS

> Rovigo, Soccorso church, *Allegory of the city;*
> Treviso, S.Maria Maddalena church, *Meal in the pharisee's house;*
> Venice, Corpus domini church, *Holy family;*
> SS.Cosmo & Damiano church, *Biblical sacrifice;*
> > Madonna dell'Orto, *The Virgin and S.Mauro;*
> > S.Moisé, *The Virgin and saints;*
> > Ospedaletto church, *Annunciation & Visitation;*
> > S.Pantalon, *Feeding of the five thousand;*
> > S.Zaccaria, *Meeting of the Virgin and S.Mary Elizabeth;*
> > Seminario patriarcale, *S.Joseph's dream;*
> > Accademia gallery, *Jesus before Caiaphas.*

ESSENTIAL BIBLIOGRAPHY

Zanetti A. M., *Della pittura veneziana*, Venice, 1771;

Bartoli F., *Le pittura della città di Rovigo*, Venice, 1793;

Moschini G. A., *La chiesa e il seminario patriarcale*, Venice, 1819;

Lanzi L., *Storia pittorica della Italia*, Bassano, 1789;

Lorenzetti G., *Venezia e il suo estuario*, Milan, 1926 (2nd ed., Rome, 1956);

Coletti L., *Catalogo delle cose d'arte di Treviso*, Rome, 1935;

Pappalardo A. M., *Il pittore veneziano A. Molinari*, in "Atti dell'Istituto Veneto di Scienze, Lettere ed Arti", 1953–4;

Galletti-Camesasca, "Enciclopedia della pittura italiana", 1950, under appropriate heading (with further bibliography);

Donzelli C., *I pittori veneti del Settecento*, Florence, 1957.

MUTTONI PIETRO

Born at Venice in 1603 and known to history as Pietro della Vecchia. According to Melchiori, he was a pupil of Padovanino. What he was taught encouraged him to resume the manner of the previous century, following Giorgione and Romanino particularly closely. His fame rests chiefly on small paintings in half-figure, with warriors and lovers certainly imitative and perhaps consciously plagiarising the master from Castelfranco in some of his works. The interpretation given them, however, was strictly seventeenth century, that is to say after the baroque manner. The characters stand against dark grounds, with brush-work full-bodied and headstrong strokes, adding a spice of drama to the tender idylls and blithe inspiration of a Giorgione.

His personality remains rather a complex one and it is only as result of modern critical evaluation that a true picture has gradually emerged. Besides painting, he was something of a man of letters and musician. It is known that he also undertook restoring and on occasion produced "antiques" which is why he came to be called Pietro della Vecchia (Of-the-old).

The *Crucifixion* of the early period in S.Lio church at Venice is indicative of an heterodox inventive genius. The three crosses rear against a stormy sky while a crowd below mills round in a flurry of colour, intense and strident. The influence of Caravaggio will not be denied, though it may have reached him through the intermediary of Saraceni's works.

In 1635 he painted the *Ascension* for S.Nicolò di Lido church. After 1640 he embarked on a new line of activity, namely designing cartoons for the craft-workers to create mosaics in St.Mark's. This field kept him busy over many years. Among other results which it bore, mention may be made of the painting, *Massacre of the Innocents*, together with mosaics in the atrium of the basilica and on the facade.

Other works expressive of his personality and deep knowledge of sixteenth century art include the scene, *Transporting the body of S.Mark; Cleansing of the temple;* and *Crossing the Red sea.* Some of his large-scale canvases are likewise noteworthy: *Noah leaving the Ark* is an example. It was painted for the presbytery of S.Antonin church at Venice and clearly shows the artist's tremendous colour potential. The group of figures raking the foreground is particularly effective and realist in the Caravaggio-derivative sense.

The group of paintings which he did for the church of S.Teonisto at Treviso is also of importance in trying to come to grips with his artistic development. They are dedicated to the martyrdom of SS.Stephen, Laurence and Sebastian. In 1954 they were cleaned and their true qualities as a consequence came to light: dramatic impact, strong chiaroscuro, colours juxtaposed so as to create a strident note, sometimes to the point of asperity. They also reflect this painter's influence upon Maffei.

The annals of his art produce some contradictory passages, when he endeavoured to reconcile the Venetian tradition of the sixteenth century with luminist painting, the dramatic style which had arrived in Venice over the early decades of the century through the example of the pro-Caravaggio painters.

Pietro Muttoni married Renieri's daughter, by name Clotilde. She was a painter too and they had many children, one of whom Gaspare in time carried on his father's work.

Pietro della Vecchia was a very prolific artist; his name was entered on the guild register of Venetian painters over the years from 1629 to 1639. He died in 1678.

He made a name for himself in his life-time as a man of many accomplishments. He was known as a good imitator of the manner of Giorgione. Lanzi remarked this talent, adding that "some of his paintings are taken for actual Giorgiones, Licinos and Titians".

In the past, this copious talent earned him renown; nowadays it can be seen as only one aspect of his wide-ranging art. Modern expert opinion deems him typically baroque with a weird and at times downright hallucinatory brand of phantasy weaving a texture richly-worked with inventive touches and the flash of moods. But Vecchia was a very good portrait-painter as well. To give some idea how original and impressive were such compositions, the portrait of the German philosopher and mathematician Erhard Wergel may serve, the artist having painted it in the year 1649.

PRINCIPAL WORKS

Augsburg, Gallery, *Violinist;*

Bassano del Grappa, Civic museum, *Two lovers;*

Carpenedo, Chiesa arcipretale, *Martyrdom of SS.Gervasio & Protasio;*

Dresden, Gemäldegalerie, *Portrait of a warrior; Saul and David with head of Goliath; Old woman beating three girls with a shoe;*

Leningrad, Hermitage, *Sacrifice of Jephthah;*

Lovere, Tavigni gallery, *Deposition of Christ sustained by angels;*

Padua, Civic museum, *Doubting Thomas;*

Rovigo, Rotonda, *Allegory of provveditor Domenico Zeno;*
Concordi academy, *Dead Christ sustained by angels;*

Treviso, Art gallery, *Martyrdom of S.Sebastian;*

Venice, S.Marco, *Transporting the body of S.Mark* (mosaic); *Massacre of the Innocents* (mosaic);
S.Antonino, *Noah leaving the Ark;*
S.Lio *Crucifixion;*
Redentore church, *The Virgin presenting Jesus to Beato Felice Capuccino;*
Academy gallery, *SS.Joseph, John and Justina* (1640).

ESSENTIAL BIBLIOGRAPHY

Boschini M., *La carta del navegar pitoresco*, Venice, 1660; *Le minere della pittura*, Venice, 1664; *Le ricche miniere della pittura veneziana*, Venice, 1674;

Zanetti A. M., *Della pittura veneziana*, Venice, 1771;

Lanzi L., *Storia pittorica dell'Italia*, Bassano, 1789;

Fiocco G., *La pittura veneziana del Seicento e del Settecento*, Verona, 1929;

Ivanoff N., *Il grottesco nella pittura veneziana del seicento*, Pietro Vecchia, in "Emporium", 1944-5;

Longhi R., *Viatico per cinque secoli di pittura veneziana*, Florence, 1946;

Ivanoff N., *La pittura metafisica nel '600 e le opere di Pietro Vecchia*, in "Vernice", 1948;

Fiocco G., *Nuovi aspetti di Pietro Vecchia;*

De Logu G., *Pittura veneziana dal XIV al XVIII secolo*, Bergamo, 1958;

Gambarin L., *Il Vecchia cartonista in San Marco*, in "Arte veneta", 1961;

Savini-Branca S., *Il collezionismo veneziano nel seicento;*

Pignatti T., *La fraglia dei pittori di Venezia*, in "Bollettino dei Musei civici Veneziani", 1965;

Donzelli C.-Pilo G. M., *I pittori del seicento veneto*, Florence, 1967 (with good bibliography).

NEGRI PIETRO

Venetian painter, born about 1635. There is scant information about his life. Even his date of birth has been deduced from the fact of the Sansovino-Martinioni catalogue naming him as a young artist, in 1663.

In 1664 he painted a picture for the church of S.Margherita, now alas lost sight of. In 1670, he was commissioned to produce the large painting of *Saints of the Franciscan order* for the Frari church at Venice. In 1673, he did the large canvas on the stair of the Scuola di S.Rocco, commemorating the plague which had ravaged Venice.

In 1677 he went to Bergamo and took part in competing for work at the church of S.Maria Maggiore by painting *Noah leaving the Ark*. The commission, nevertheless, went to another artist, Federico Cervelli. After this date, no more information has emerged so that he may be assumed to have died within a little.

As Zanetti pointed out, Negri was quite close to Zanchi and his manner was likewise similar with intense and dramatic use of chiaroscuro. Negri nevertheless "at times achieved greater stature though with regard to the colour scale he disliked the clear light of day as heartily as the other" (Zanetti, 1792). Moschini (1815) mentioned the connection with Zanchi, as did Lanzi.

Modern experts have, on the other hand, tended to emphasise an association of manner between himself and Ruschi, of whom he was probably a follower. Arslan (1946) wrote that in respect of drapery, Negri and Ruschi were aligned but when it came to his hot and strong colour material, then there seemed to be a connection with Rivera and indeed Pietro Vecchia.

It may be added that the works of his prime have a new formal elegance and gentler colouring, perhaps due to contact with Renieri and the work of the young Carpioni. Anyhow, the aggressiveness of the Caravaggio stream lost ground in his later work; he embarked instead on a rather melodramatic kind of composition. This was in line with the manner of painting becoming general by the close of the century, and which gained in prominence through the endeavours of Balestra, Celesti and other painters of that time.

PRINCIPAL WORKS

Arbizzano, Parish church, *Altar-piece dedicated to All saints;*
Dresden, Gemäldegalerie, *Nero & Agrippina;*
Rovigo, Concordi academy, *Rebecca at the well; The Magdalene;*
Venice, Carmelite church, *The Virgin appearing to a carmelite saint;*
 Frari church, *Saints of the franciscan order;*
 Scuola di S.Rocco (stairway), *The plague at Venice;*
 S.Maria Formosa, *The dead Christ;*
 Academy gallery, *Jesus and the woman of Samaria.*

ESSENTIAL BIBLIOGRAPHY

Sansovino F.–Martinioni G., *Venetia città nobilissima et singolare*, Venice, 1663;

Boschini M., *Le minere della pittura*, Venice, 1664; *Le ricche minere della pittura veneziana*, Venice, 1674;

Zanetti A. M., *Descrizione di tutte le pubbliche pitture di Venezia*, Venice, 1733;

Lanzi L., *Storia pittorica dell'Italia*, Bassano, 1779;

Zanetti A. M., *Della pittura veneziana*, Venice, 1771;

Moschini G. A., *Guida per la città di Venezia*, Venice, 1815;

Fiocco G., *La pittura veneziana del Seicento e Settecento*, Verona, 1929;

Arslan W., *Il concetto di luminismo e la pittura veneta barocca*, Milan, 1946;

De Logu G., *Pittura veneziana dal XIV al XVIII secolo*, Bergamo, 1958;

Zampetti P., in "La pittura del Seicento a Venezia", (Exhibition catalogue), Venice, 1959;

Donzelli C.–Pilo G. M., *I pittori del Seicento veneto*, Florence, 1967.

PAGANI PAOLO

Born at Castello Valsolda in about 1660, he moved to Venice where he seems to have become a pupil of Pietro Liberi. Zanetti held him "happily inventive and a painter of real genius". Lanzi (1789) also found him praiseworthy, adding that he began a new style of "drawing from the nude, fairly emphatic but still seemly".

Pagani's being in Venice during the baroque-rococo crisis of transition was not without impact. It is only recently that it has become the focus of critical attention. The task of re-creating the personality of this artist (as undertaken by Voss, Arslan and Ivanoff) is a somewhat arduous and complex one. What is generally admissible is that he brought with him to Venice a manner of painting referable to Lombard origins.

But it is not impossible that he knew about Genoa painting, then so far ahead of the times. For instance, his arrangement of colouring with subtle and vibrant contrasts (azure and yellow, red, or grey luminously rendered) call to mind the work of Bartolomeo Guidobono. This pleasant dreamy painter was already moving—along with other artists of Liguris—very much towards the harmonious refinement of form coalescing in rococo.

Contact with Venetian painting meant the enlarging of Pagani's range in the exploitation of colour; at the same time, he enriched Venetian painting by invigorating aspects of composition. Among the benefits he contributed, mention may be made of the fact that he was Gian Antonio Pellegrini's master. Recently, Pilo has further suggested him as a possible formative influence on Federico Bencovich.

The work of evaluating this artist may be dated back to the studies by Voss (1929), concerning the Castello di Valsolda frescoes which are signed. His style was of undoubted elegance and also of quite unusual pictorial effect. His influence on Venetian painting was noteworthy though a full definition of his output is hampered by having so small a total of assigned works.

Paolo Pagani died at Milan in the year 1716.

PRINCIPAL WORKS

Castello Valsolda, Parish church, *Frescoes* (Assumption, John baptist preaching, Glory of S.Martin);

Chiusa, Capuchin church, *Madonna and child;*

Como, Civic museum, *Descent to Limbo;*
Cracow, S.Anna, *S.Sebastian;*
Dresden, Gemäladegalerie, *The Magdalene;*
Venice, S.Maria Formosa, *S.Peter;*
 Palazzo Salvioni, *Sacrifice of Isaac; Hagar in the wilderness.*

ESSENTIAL BIBLIOGRAPHY

Zanetti A. M., *Descrizione di tutte le pitture della città di Venezia*, Venice, 1733;

Orlandi P. A.–Guarienti P., *Abecedario pittorico*, Venice, 1753;

Zanetti A. M., *Della pittura veneziana*, Venice, 1771;

Lanzi L., *Storia pittorica della Italia*, Bassano, 1789;

Voss H., Paolo Pagani, *Versuch einer Rekonstituierung*, in "Belvedere" VIII, 1929;

Arslan W., *Chiarimento a Paolo Pagani*, in "Archivio per l'Alto Adige", 1935;

Voss H., *L'affresco di Valsolda e altre opere inedite di Paolo Pagani*, in "Rivista archeologica . . . di Como";

Ivanoff N., *Il problema di Paolo Pagani*, in "Paragone", 1957;

De Logu G., *Pittura veneziana dal XIV al XVIII secolo*, Bergamo, 1958;

Martini E., *La pittura veneziana del Settecento*, Venice, 1964;

Donzelli C.–Pilo G. M., *I pittori del Seicento veneto*, Florence, 1967 (with further bibliography).

PELLEGRINI GIAN ANTONIO (1675–1741)

Born at Venice on 29 April 1675, he was the son of a glove-maker, of Paduan origin. At a tender age, he became a pupil of Paolo Pagani and went with him to Austria where he remained some six years.

In 1696 Gian Antonio had returned and was busy painting the Castello di Valsolda frescoes. The Austrian journey was the first of many which took him the length and breadth of Europe. How important this was in shaping his own artistic development and in affecting the course of European art will be shewn in this article.

The journey he made to Rome, mentioned by Mariette (1851–60), probably took place in 1699. The great fresco cycles in the baroque churches must have influenced his outlook and the work of Baciccia in particular, a personality famed not only for the great Chiesa del Gesù vaulted ceiling but in addition for his little canvas paintings. In these, some memory of the great Correggio was kept alive through the medium of teaching from the Genoa school, the out-and-out precursor of the rococo movement in Europe.

Returned to Venice in 1701, Pellegrini undertook the first big job of his quite extraordinarily active career, namely the three canvases ordered from him by Francesco Federici for the Scuola del Cristo in S.Marcuola. Work followed at Padua and in Venice. In 1704 he married Rosalba Carriera's younger sister, by name Angela. Much of the information handed down about this artist is attributable to her, in that she wrote a letter to Mariette about him.

In 1708 he was on the move again. An artist in his prime, having experimented widely not only after the fashion of Venetian painters (of Ricci especially) but other Italian artists: Luca Giordano first and foremost, known from the outset through his Venetian reputation. He was very attentive to Roman art, which as it were contained the art experience of the Italian seventeenth century. In

1708, Charles Montagu then Viscount and later Duke of Manchester (the same notable Carlevarijs celebrated in painting his sumptuous arrival at Riva degli Schiavoni) came to Venice as the representative of his sovereign Queen Anne and took a keen interest in the artist.

As Bettagno (1959) remarked, it was probably the famous Rosalba who spoke up for his talents. The English nobleman went home and with him went Pellegrini and the young and brilliant Marco Ricci. Undoubtedly, these two artists' visit to England was very significant in cultivating taste. While at London, Pellegrini was kept very busy and produced many works for his eager patrons.

The frescoes which he did at Castle Howard were unfortunately destroyed in the war, 1941. But he also worked at Montagu house and at Kimbolton, painting the staircase. In short, he soon earned a stunning reputation.

In 1715 there was some disagreement with Marco Ricci, who meanwhile had invited his uncle Sebastiano to London. Pellegrini deemed it prudent to leave London and indeed England, and become a roving painter once again. It may have been his preference or a wish to change the scene; at all events, it was a kind of life quite customary in that age, and enabled him to keep abreast of all the new work in the artistic field at a given time.

In 1715 he was in Germany, at the court of the Elector palatine Johann Wilhelm in Düsseldorf for whom he painted decorative themes at Schleissheim castle in Bavaria. The work was done, when his patron died and he moved on, into Belgium and Holland.

His fame grew and his output along with it. He never stayed anywhere for very long. In 1719 he was at the Hague, London, Paris and so home to Venice working at high pitch all the time (Bettagno, 1959). In 1720 he was back in Paris, painting the Mississipi gallery at the Banque royale, a commission accorded him by the duke of Orleans, then Regent of France. The work has, unfortunately, not survived but knowing the level of refinement and sense of spaciousness he had achieved by this period, it is not hard to imagine the extent of his influence on nascent French rococo.

In Paris he remained a whole year before returning to Venice. In 1722 he was in Bavaria and in Paris again. From the French capital the artist travelled to Wurzburg and Dresden before going back to Venice. But he was not at home long; this time he went to Vienna, where he had stopped on the way back from Dresden. In Vienna he painted the cupola of the Salesian church and the altar-piece for the church of S.Carlo.

Returning to Venice, he began to work in the Veneto. To this period belong the decorative paintings in the Basilica del Santo at Padua. In 1733, he was elected to membership of the Academy in Paris. In 1736 he left Italy for Germany and frescoed four ceilings at Mannheim castle though the work was destroyed in the course of the Second world war. In 1737 he came home to Venice for the last time and died there on 5 November 1741.

Of great fame in his life-time, as indicated, in court circles all over Europe, Pellegrini's personality fell into disesteem and near-oblivion about the end of the century (as happened with nearly all practitioners of rococo art). Scholars have been reconsidering his position more recently, and the consensus is that his complex character was a vital disseminating influence, the manner he practised becoming the standard in polite society with ensuing results in terms of European art.

It must not, however, be forgotten that his admirers were not only his princely patrons but connoisseurs of the mark of Mariette, also Cochin (1758) and Zanetti (1771) who saw his good side and called it "most felicitous". This Venetian annalist painted a lively enough word-picture of the genial-natured man as well as the artist. His spacious sanguine touch, understood properly as the utterance of a particular phase of civilisation in Europe, cultivated indeed to be treasured but lapsing like rococo for all its exalted tones into decline. Lanzi (1789) was not of the same mind; he thought "the great fortune he enjoyed in the most civilised kingdoms of Europe was owing to the decay of

art . . . he painted unincisively so that things sometimes hover between being there and not there, as it were unseen and seen".

Lanzi, a painstaking and perceptive critic ever, gave as defects (due less to the man than the age) what are in fact Pellegrini's leading merits forgotten for upwards of a century until research into eighteenth-century painting was resumed, the re-establishment of his name being attributable in particular to the efforts of Voss in that direction.

Longhi (1946) in his "Viatico" also referred to Pellegrini's extraordinary quality of paint with special emphasis on the "unseen and seen" aspect which Lanzi disliked (but noted) as expressive of "the new century at its most capricious, the treatment of form so casual it is barely evocative upon the air". But as Longhi affirmed, "Pellegrini's Paris ceiling for the Banque royale (1720) was probably a decisive factor in the formation of the French manner of the eighteenth century".

Indeed, modern work concerning this artist has tended to lay stress on his role as an influence in terms of European painting. Scholars such as Arslan, Watson, Morassi, Pallucchini and Bettagno have all helped give this artist his due as a fore-runner and exemplar of the rarefied heights of rococo.

PRINCIPAL WORKS

Budapest, Fine arts museum, *The cripple healed;*
London, National gallery, *Rebecca at the well;*
 Paul Wallraf coll., *Bacchanal;*
 Denys Sutton coll., *S.Sebastian hidden by holy women;*
 Denis Mahon coll., *Biblical scene;*
Mannheim, Castle museum, *Four ceiling frescoes;*
Oxford, Ashmolean museum, *Allegory of the dawn* (model for a ceiling);
Padua, Duomo, *Madonna and saints;*
Posen, Museum, *Sacrifice of Polyxena;*
Pommersfelden, Schonborn castle, *Bathsheba bathing;*
Rome, Rocchetti coll., *Moses in the bullrushes; Bathsheba;*
Schleissheim, The castle, *Allegory of war; Triumph of prince Johann Wilhelm; S.Sebastian* (on deposit at Munich);
Venice, San Moise church, *Moses and the serpent;*
 San Stae church, *Crucifixion of S.Andrew;*
 San Vidal church, *Martyrdom of S.Vitale;*
 San Zaccaria church, *San Zaccaria in glory.*

ESSENTIAL BIBLIOGRAPHY

Zanetti A. M., *Descrizione delle pubbliche pitture,* Venice, 1733;
Cochin N., *Voyage d'Italie,* Paris, 1758;
Zanetti A. M., *Della pittura veneziana,* Venice, 1771;
Moschini G. A., *Guida per la città di Venezia,* Venice, 1815;
Sensier R., *Journal de R. Carriera pendant son séjour à Paris . . .,* Paris, 1875;
Fiocco G., *La pittura veneziana del '600 & '700,* Verona, 1929;
Goering M., *Pellegrini-Studien,* in "Münchener Jahrbuch der Bildenden Kunst", 1937–8; *Eine Gemäldeskizze von G. A. Pellegrini,* in "Wallraf Richartz Jahrbuch", 1941–3;
Arslan W., *Il concetto di luminismo e la pittura veneta barocca,* Milan, 1946;
Pallucchini R., *Modelli di G. A. Pellegrini,* in "Arte Veneta", 1953;

Watson F. J. B., *English villas and Venetian decorators*, in "Journal of the Royal Institute of British Architects", 3rd series, vol. 61, no date;

Bettagno A., *Disegni e dipinti di G. A. Pellegrini*, Venice, 1959;

Pallucchini R., *La pittura veneziana del Settecento*, Venice-Rome, 1960;

Martini E., *La pittura veneziana del Settecento*, Venice, 1964;

Gregori M., *Osservazioni a proposito degli abozzi del Pellegrini*, in "Paragone", 1960;

Griseri A., *Una antologia del disegno veneziano del '700*, in "Arte Veneta", 1966;

Pilo G. M., *Ricci, Pellegrini, Amigoni, nuovi appunti su un rapporto vicendevole*, in "Arte antica e moderna", 1960;

Zampetti P., *Dal Ricci al Tiepolo* (Exhibiton catalogue), Venice, 1969 (with bibliography to date).

RICCI MARCO

He was born at Belluno on 5 June 1676. It is possible that his uncle Sebastiano was his first teacher, seventeen years his senior but who outlived him. It is certain that his temperament soon led him in other directions than those his famous relative pursued. Although progress has been made up to a point in trying to trace the origins of Marco's artistic vocabulary, pretty well everything remains to be said on this subject.

The first known works from his hand tend to lay stress on the landscape element. In this realm he became an authority in Venice and was perhaps the leading exponent. According to Temanza (1738), Marco spent an irregular youth, being high-spirited to excess. On one occasion he fell into a quarrel with a gondolier in a tavern, hit the man over the head with his tankard and killed him. To escape the legal consequences, Temanza further recorded that his uncle then sent him away to Spalato where he lived over a period of four years under the eye of "a good landscape painter, from whom he learned a great deal". When the risk of prosecution was over, he returned to Venice. Whether he really went to Dalmatia in order to lie low is not altogether accepted; let it be said that modern scholars feel there is a margin of doubt.

Recently, it has been argued that the "good landscape painter" mentioned by Temanza was none other than Antonio Francesco Peruzzini of Ancona, of central and southern Italian culture and therefore expressive of the pre-Romantic stream in landscape art capped by the work of Salvator Rosa. Peruzzini is also known to have enjoyed working relations with Magnasco; indeed, they collaborated in Lombardy—and Magnasco was another artist to whom Marco looked for guidance, especially in his years of maturity.

Were this notion to fit the case, it would go a long way to explaining the extra-Venetian elements in Ricci's art, namely his liking for a blaze of paint material, no less strong-headed when it came to choice of theme and singularly outspoken in the context of lagoon training between a Celesti and a Bellucci.

The young artist was no stay-at-home. He liked to be on the move, after new sights. Gamba took the view that he went to Florence with his uncle who frescoed the hall of Palazzo Maruzzelli. He is known to have been at Florence: he wrote as much in a letter of 1727 (Bottari) though without giving a date. He had also been to Rome. When did he meet Magnasco? Probably as a young man, about 1705, at a period associated by De Logu (1931) with a rare landscape piece. On the dorse of the canvas, a legend states that it was the work of four hands, i.e. four artists and two of them were in fact Alessandro Magnasco and Marco Ricci.

In 1708 Charles Montague, Duke of Manchester on a diplomatic mission to Venice invited Ricci (and Pellegrini with him) to accompany him back to England. The artist was already known there, having sold some twenty works through lord Irwin. Pellegrini and Ricci, having arrived in England, were commissioned to paint sets for the Italian opera at the Queen's theatre in the Haymarket. The two artists had some kind of a disagreement and the result was that Ricci went back to Italy, probably in 1710. But in 1712 he was in London again, this time his uncle Sebastian with him. They both stayed on until 1716, the year they returned home together. Marco went to live at his uncle's in Calle del Selvadego, behind Piazza San Marco and it remained his address till he died—though on several occasions he paid visits to other cities, including one journey to Rome that Arslan dated to about 1720.

Marco Ricci's career as an artist is full of surprises, sudden outbursts in ever-changing directions, not readily to be understood.

In youth, there is a kind of general influence at work deriving from the Neapolitan manner of dealing with landscape subjects rather fiercely, and this may be taken as inspired by the art of Salvator Rosa. However, he was loyal to his illustrious Venetian predecessors and learnt from Titian as Zanetti (1771) his first biographer observed.

No doubt but that multiple sources contributed to his formative period, for the reason that he was by nature open-minded and inquisitive. His thirst for knowing remained quite unappeased throughout his short span of life. He studied the landscape interpretations of a Carlevarijs and the exchange may have worked both ways, more to the benefit of the senior but less brilliant of the two painters from Friuli.

A letter of Gabburri shows how deep was Ricci's involvement with the canons of his art, being quick to remark that the technique of the great masters of the past was not like the present, indeed that it was not serviceable for the "style nowadays required". The precise wording covers a world of anxiety over the outcome of the creative process, the artist being continually stretched in trying to make some headway and cause constant renewal of the painting manner then practised. It was for this motive that he studied Magnasco with his subtle and allusive forms of expression, his understating of positions moral and religious, not always responding direct to a deep human impulse. Lastly, it was this same motive which turned his attention to ruins as a landscape feature and thus led to the making of his "capricci". The caprice paintings were a slow growth and may have owed something to contact with Pannini. At all events, they mark the high-point of his late period.

A restless painter, Marco Ricci set about discovering, learning from and inwardly digesting the sprightliest examples of phantasy view-painting. As a person, he is a rather mysterious shadowy figure (though some inkling of a strange sad character may be gleaned from caricatures by Zanetti). As an artist, he holds a unique place in the annals of Venetian painting (with particular reference to his interpretation of the caprice, shot with light and of such dramatic impact it might be termed pre-Romantic in feeling).

It is evident that Carlevarijs was a source of influence but Ricci goes beyond him in the sense of staging his caprices in ruin settings. When Carlevarijs turned to lagoon view-painting, at a later period, Ricci's interest was lacking. His career may not be unconnected with the start of that of Canaletto.

In late paintings, the focus fixed more on the landscape, Marco enjoyed the painstaking collaboration of his uncle Sebastiano, who painted in the little figures of people. It was a reciprocal arrangement, the nephew then proceeding to do the landscape grounds for the uncle's large-scale compositions on sacred subjects.

To the last, striving to capture the quality of light, Marco continued view-painting, with some small landscapes and country pieces, many done in tempera perhaps after the example of Gaspare

van Wittel. His engravings are splendid works, revealing a rare technical skill in the handling of effects of light.

Marco Ricci died on 21 January 1730 of a pulmonary complaint and not self-murder as Temanza would have it.

PRINCIPAL WORKS

 Bassano, Museum, *Seascape in storm;*
 Belluno, Nicolis coll., *Landscape* with shore and ruins;
 Civic museum, *Landscape;*
 Bergamo, Carrara Academy, *Landscape;*
 Bologna, Art gallery, *Seascape in storm;*
 Dresden, Gallery, *Winter scene;*
 Edinburgh, National gallery, *Landscape with monks;*
 Hartford, Wadsworth Athenæum, *Architectural remains;*
 Kassel, Gallery, *Landscape with ruins;*
 London, Haward coll., *Walking in St. James' park;*
 Buckingham palace, *Rustic court;*
 Milan, Sforza castle, *Landscape with ruins;*
 Padua, Civic museum, *Communion of S.Jerome* (in collaboration with Sebastiano Ricci);
 Parma, Berilla coll., *Caprice painting* with ruins and figure;
 Venice, Querini Stampalia coll., *Stormy scene;*
 Accademia gallery, *Landscape with monks and washerwoman;*
 Vicenza, Civic museum, *Landscape with ruins.*

ESSENTIAL BIBLIOGRAPHY

 Zanetti A. M., *Compendio delle vite dei pittori*, Venice, 1733;
 Temanza T., *Zibaldon di memorie storiche* etc., Venice, 1738 (ed. Ivanoff, Venice, 1963);
 Moschini G. A., *Della letterature veneziana*, Venice, 1806;
 Ticozzi S., *Dizionario dei pittori*, Milan, 1818;
 Damerini G., *I pittori veneziani del Settecento*, Bologna, 1928;
 Fiocco G., *La pittura veneziana del '600 & '700*, Bologna, 1929;
 De Logu G., *I pittori veneti minori del Settecento*, Venice, 1930;
 Blunt A., *Paintings by Sebastiano and Marco Ricci in The Royal Collection*, in "The Burlington Magazine", 1946;
 Petrucci A., *Le pazze invenzioni di Marco Ricci,* in "Emporium", 1946;
 Blunt A., *Sebastiano and Marco Ricci*, in "The Burlington Magazine", 1947;
 Ivanoff N., *Questioni riccesche*, in "Emporium", 1948;
 Watson F. J. B., *Eighteenth century Venice*, London, 1951;
 Valcanover F., *Catalogo della Mostra di pittura del Settecento nel bellunese* (Exhibition catalogue), Venice, 1954;
 Blunt A. & Croft-Murray E., *Venetian drawings of the XVII & XVIII centuries in the collection of Her Majesty the Queen at Windsor Castle*, London, 1957;
 Donzelli C., *I pittori veneti del Settecento*, Florence, 1957;
 Pallucchini R., *La pittura veneziana del Settecento*, Venice-Rome, 1960;

Pilo G. M., *Marco Ricci* (Exhibition catalogue), Venice, 1963;

Levey M., *The later Italian pictures* in the collection of Her Majesty the
 Queen, London, 1964;

Martini F., *La pittura veneziana del Settecento*, Venice, 1964;

Zampetti P., *I vedutisti veneziani del Settecento*, Venice, 1967 (with biblio-
 graphy to that date);

Pilo G. M., *Inediti di Marco Ricci*, in "Arte Illustrata" 1969.

RICCI SEBASTIANO (1659-1734)

Born at Belluno in 1659, he went away to Venice at the age of twelve and became a pupil first of Federico Cervelli and then of Sebastiano Mazzoni, a Florentine painter living in the city and responsible for a new and fruitful manner cultivated by his strangely appealing phantastic spirit.

It is not impossible that there was also an early contact with the stimulating personality of Luca Giordano over the formative period when the Neapolitan was often at Venice leaving works from the year.

Ricci's training was not soon complete, for he welcomed a breadth of experience. In 1678 when Mazzoni died, he went to Bologna and learnt a good deal from the leading exemplars of the flourishing local school. At the close of his Bologna period, Ricci produced the first evidence of his work in two altar-pieces, done for the company of S.Giovanni dei Fiorentini and since lost, and in the output from a visit to Parma at the invitation of duke Ranuccio II Farnese.

Between 1685 and 1687, together with Bibbiena, he completed the frescoing of the oratory of Madonna del Serraglio at S.Secondo di Parma (Ghidiglia Quintavalle A., 1956–7). To the same epoch belongs a group of works for Parma university (*Antiochus visited by doctors, Diogenes, Diogenes and Alexander, Mucius Scævola, Lucretia*). They have the colour range of the Veneto, deriving from Bellucci, but this is fused with chiaroscuro impasto and a very naturalist streak acquired while at Bologna and part attributable to the late "tenebrosi" then active at Venice.

The fact of the S.Secondo frescoes being mellowed by examples from Emilia and out of Correggio suggests a later date, even if the difference is only marginal.

At the invitation of Farnese, Sebastiano Ricci next went to Rome where he would have seen the frescoes done by the Caraccis for the palace belonging to his patron's family, and had his interest awakened by the expansive cycles of fresco-paintings, the work of Pietro da Cortona and the Genoese painter Gaulli who also created the breathtaking vault of the Gesù church which went as far as Roman baroque could in the direction of rococo.

According to Pascoli (1730–6), the artist left Rome in 1694 on the death of Ranuccio II and went via Florence into Lombardy. From this time date the *Angel saving the child* of S.Maria del Carmine church at Pavia and also the *frescoes* of the cupola supports at S.Bernardino dei Morti in Milan (1695–8).

In these works there is plenty of evidence of his art undergoing renewal. The Pavia altar-piece embodies extremely mobile figures, their movements counterpoised and this may be taken as indicative that Baciccia's teaching had not gone unheard. The elements from Caravaggio come to the fore, together with echoes of Roman baroque, in the Milan frescoes and the attempt to present a suffused quality of light is already apparent.

From Milan, the artist returned to the Veneto and home ground, working round Belluno on the frescoes for Casa Fulcis-De Bertoldi, which accentuate certain tendencies incipient at Milan. His endeavour lay in solving the problem of making the dynamics of composition taught by Roman baroque art more reactive to light. This, at the threshold of a new century when Ricci found himself in a mature enough position to contribute positively to the task of releasing painting from

the chiaroscuro dead-weight handed down from the seventeenth century. He moved instead to a more serene mood of painting open to re-formulate classical ideals.

The *ceilings* of Palazzo Querini Stampalia in Venice indicate this development under way, though there are still passages of violence in the composition. His Padua activity of this period associated with the decorative scheme for the basilica of S.Giustina shows his clear-felt need to break away from the Venetian baroque tradition, his helpful Roman experience having already set him at one remove distant. Then began his great leap backwards in time, which brought him to the feet of the artist he found most like-minded and at one and the same time the fount of the great Venetian post-Renaissance tradition of painting, namely to Paolo Veronese.

The period of crisis when he was searching for a new rhythm of composition and a new quality of light, as the new century dawned, followed its course. The "new" group of works which he did for Parma (university) indicate this process, offering a contrast between his sensitivity at that date as compared with the early evidence.

After Parma, the *canvases* at S.Marziale in Venice (c. 1704), the *frescoes* of Palazzo Marucelli and Palazzo Pitti in Florence (1706–7) whither the artist went at the invitation of prince Ferdinando de' Medici, the *altar-piece* of S.Giorgio Maggiore in Venice (1708): these represent the main stages in Ricci's progress as an artist and in so doing, the re-vitalising of Venetian painting on the move towards a new manner as the inheritance of Veronese found fresh meaning in the full light of the sun. His encounter with work of Luca Giordano was undoubtedly fruitful. Ricci's greatest triumphs seem to follow on from the great Neapolitan's labours. The frescoes at Palazzo Medici Riccardi in Florence must have been significant to this effect.

The great ceiling at Palazzo Marucelli with its *Hercules received in Olympus* has a lightness of touch, the treatment of space and perspective deriving from Roman sources. Again, it may be seen to more dazzling effect in *The meeting of Diana and Acteon*, where progress in the sense of festive rococo painting calls to mind the felicitous precedents of Genoa work as instanced by a Gregorio De Ferrari.

The S.Giorgio Maggiore altar-piece is fundamental for the new direction being taken by Venetian painting: the chromatic scale carries signs of preciosity, the treatment of light is transparent, and the whole manner including formal aspects is evocative of the art of Paolo Veronese.

While at Milan in the year 1711, Sebastiano made the acquaintance of Magnasco. From his influence, Ricci's painting gained a new rather impressive nerviness of brush-work. To this period, immediately prior to his first journey to London in 1712, belong some major items including the *Assunta* of Clusone, the altar-piece of the Certosa di Vedana (*The Madonna appearing* and *Baptism of Christ*), also the *Temptations of S.Anthony* of Schleissheim castle and *Landscapes with monks* of Epinal museum.

From 1712 he was in London with his nephew Marco. At this point, the zestful painting of Pellegrini was not without its influence on him. However, he was beginning to follow the lead given by Veronese still more openly, interpreted in his painting by brushwork of greater fluidity more widely spread, the selection of material sometimes verging on the over-refined. There are some splendid pieces from this phase of his life, as the ones at Burlington house (now The Royal Academy in Piccadilly), comprising mythological scenes done in collaboration with Marco who painted in the landscape grounds.

In 1716 Ricci went to Paris and received an invitation from the Academie française for which body he did an allegorical painting now at the Louvre. Then back he went to Venice and there he remained. While at Paris, Crozat had presented to him Antoine Watteau, a young painter of stature if not yet acclaimed (Letter 32, Crozat to La Carriera, in "Gallerie nazionali italiane", 1899, IV).

His work went on as felicitously as ever. About 1720 he produced the *Glory of learning*, a ceiling

painting for the Seminary library at Venice. Then for the court of the house of Savoy at Turin, he painted several canvases for the Castello di Rivoli and Palazzo reale, now at the Sabauda gallery. There were others, for the basilica of Superga and four over-lintels for La Veneria, painted between 1724 and 1735.

His extensive Piedmont experience refined his colour treatment and light texture to an elegance of incomparable pitch, see *The repudiation of Agar* and *Solomon and the graven images*. There was a certain headiness in this kind of painting, which once the heights had been reached seems to show a slackening pace and settle to a premature neo-classical formula as it were; a similar phenomenon apparently transpired in respect of Amigoni and his late Spanish period.

To Ricci's late period, between 1726 and 1729, belong the Hampton court examples of his work, done for Joseph Smith then the English consul at Venice. Marco collaborated in their production but Sebastiano's hand had lost none of its skill and they rank as masterpieces of Venetian rococo (remembering that the echoes out of Veronese remained a constant in his work, contrariwise to their gradual fading in the work of Pellegrini).

He left a good many paintings from the late period at his house in Calle del Selvadego (by S.Mark's), for his last will and testament inventories the paintings in his possession. His continual search for new achievements was sustained meanwhile, as shewn by altar-pieces (the *Madonna and the Guardian angel* in the Scuola of that name at Venice; *S.Gregory* and souls undergoing purgation in the church of S.Alessandro della Croce at Bergamo, among others).

Sebastiano Ricci died at Venice in 1734, having just completed a further two altar-pieces, one for the church of the Gesuati and the other for that of S.Rocco.

He was an artist of a wide cultural horizon, responsive to new demands in the manner of later rococo definition; at the same time he cultivated the Venetian tradition of painting with acumen especially in the light of work of the sixteenth century. By comparison with Liberi who was similarly associated with sixteenth century precedents, his feeling was rather for re-presenting than repeating lessons learned earlier. His work was of undoubted importance in helping improve the quality of Venetian art in the eighteenth century. His bravura and breadth of grasp was recognised by his contemporaries, namely Zanetti, Pasta and Cochin who all found his endeavours praiseworthy. The first Italian art historian, the abbot Lanzi (1789), though living during the neo-classical period (and bearing in mind that the world of Ricci abounded in pro-classical reforms) distinguished his true value in terms of artistry and may be cited today by way of a fair appraisal.

"Amidst such a variety of schools, he reaped a harvest of fine images; by copying many, he became skilled in many styles . . . the richest reward of his travels was that—whatever the subject in hand— he would think it over in the way of this or that master, profiting thereby without taking direct . . . His figures have the beauty, nobility and grace of form out of Paolo; their poses are quite extraordinarily natural, they are also apt and inconceivably varied; the compositions follow the dictates of truth and good sense".

Before this, d'Argenville (1762) had stressed how fertile was Ricci's mind, the balance and fresh chromatic thinking of his compositions. In the nineteenth century and especially during the Romantic era, he became a shadowy figure though interest in him revived when the experts began to take a closer look at painting in the eighteenth century.

Longhi in his "Viatico" (1945) took up Lanzi's point about Ricci's precedents in pictorial terms and deemed him of European culture. Compared with certain examples of cultural imbalance, Ricci achieved a rapid, select and richly coloured painting style in line with rococo at its most refined; Longhi added that Ricci's "bozzetti" are like a fore-taste of Fragonard.

Since then, work concerning Ricci has multiplied, the importance of his personality in the development of rococo, not only in Italy but throughout Europe, becoming better understood and at deeper levels.

PRINCIPAL WORKS

Belluno, Palazzo de' Bertoldi, *Fall of Phæton;*
Budapest, Museum, *Assumption of the Virgin; Bathsheba bathing;*
Chatsworth, The Trustees of the Chatsworth estates, *Marriage at Cana;*
Dresden, Gemäldegalerie, *Offering to Vesta;*
Florence, Palazzo Pitti, *Triumph of Diana and Acteon;*
 Palazzo Marucelli, *Mythological scenes* (frescoes);
London, Royal Academy, *Frescoes;*
 Hampton Court, *Moses in the bullrushes; Continence of Scipio; Adoration*
 of the shepherds; Love and Titan; Moses striking water from the rock.
Milan, Lutomirskj coll., *Rest on flight;*
Parma, Palazzo dell'università, *Junius Brutus; Cincinnatus; Rape of Helen;*
Pavia, S.Maria del Carmine, *Guardian angel;*
Pommersfelden, Schönborn castle, *Bacchus & Ariadne;*
Springfield, Museum, *Assumption;*
Turin, Sabauda gallery, *Flight of Agar; Solomon and the graven images; Moses*
 striking water from the rock;
Vedana, The Certosa church, *Baptism of Christ;*
Venice, German evangelical church (ex- Scuola dell'Angelo custode),
 Madonna in glory and Guardian angel saving a child;
 Church of S.Giorgio maggiore, *Madonna enthroned and saints;*
 Church of S.Rocco, *Miracle of S.Francesco di Paola;* ·
Vicenza, S.Marco church, *Ecstasy of S.Teresa;*
Vienna, S.Carlo church, *Assumption with apostles;*
 Kunsthistorisches museum, *Christ in the garden of Olives.*

ESSENTIAL BIBLIOGRAPHY

Pascoli L., *Vite de' pittori,* etc., Rome, 1730–6;
Zanetti A. M., *Descrizione di tutte le pubbliche pitture,* Venice, 1732–3;
Orlandi P., *Abecedario pittorico,* Venice, 1753;
Cochin N., *Voyage d'Italie . . .,* Paris, 1758;
Longhi A., *Compendio delle vite dei pittori veneziani,* Venice, 1762;
Zanetti A. M., *Della pittura veneziana,* Venice, 1771;
Ruta C., *Guida di Parma,* 1780;
Lanzi L., *Storia pittorica della Italia,* Bassano, 1789;
Moschini G. A., *Guida per la città di Venezia,* Venice, 1815;
Mariette P., *Abecedario,* in "Archives de l'art français", 1854–7;
Frimmel T., *Catalogo dei quadri del Conte di Schömborn,* Pommersfelden,
 1894;
Derschan J., *Sebastiano Ricci,* Heidelberg, 1922;
Fiocco G., *La pittura veneziana del Seicento e Settecento,* Verona, 1929;
Arslan W., *Opere inedite di Sebastiano Ricci,* in "Gazette des Beaux Arts",
 1935;
Blunt A., *Paintings by Sebastiano and Marco Ricci in the Royal collection,* in
 "The Burlington Magazine", 1946;

Watson F. J. B., *Sebastiano Ricci as a Pasticheur*, in "The Burlington Maga-
zine", 1948;

Pallucchini R., *Studi ricceschi*, in "Arte Veneta", 1952;

Watson F. J. B., *English villas and Venetian decorators*, R.I.B.A. Journal,
see No 89, 3rd series, No 61;

Levey M., *The eighteenth century Italian school*, London, 1956;

Donzelli C., *I pittori veneti del Settecento*, Florence, 1957;

Mariacher G., in *"Le pittura del Seicento e Venezia"* Catalogo della Mostra,
Ce Pesaro, Venice 1959;

Pallucchini R., *La pittura veneziana del Settecento*, Venice-Rome, 1960;

Levey M., *The later Italian pictures in the Collection of Her Majesty the Queen*,
London, 1964;

Martini E., *La pittura veneziana del Settecento*, Venice, 1964;

Pignatti T., *I disegni veneziani del Settecento*, Treviso, 1966;

Zampetti P., *Dal Ricci al Tiepolo*, Exhibition catalogue, Venice, 1969
(with further bibliography).

RICHTER GIOVANNI

Born in 1665 at Stockholm and probably started his training in that country, he was brother to the
miniature painter David. About 1695 he left Sweden and took up residence at a precise date un-
known in Venice where he lived until his death on 27 December 1745.

In the city of the lagoons he knew Carlevarijs and seems close to this artist, especially in early
productions. His views are presented with luminous clarity and according to a precise scheme of
perspective.

Later, he drew closer to Canaletto though his work maintains the clear imprint of an individual
character. In his view-paintings are set little figures of vivacity and vivid colouring; their function
to add a note of emphasis to the fore-ground balanced against the distant background perspective.
In the past, much of his work was confused with that of Canaletto; this may have begun in the
eighteenth-century, when Venetian view-paintings were all the rage especially in England.

No great number of works is attributed to him nowadays but as far as can be judged the evidence
points to a modest level of attainment as a painter.

PRINCIPAL WORKS

> Florence, Campi coll., *Imaginary landscape;*
> Windsor castle (UK), *Islands of S.Cristoforo & S.Michele;*
> Munich, Fischmann coll., *Le Zattere;*
> Stockholm, National museum, *Island of S.Giorgio; S.Michele in isola;*
> > Siren coll., *View of Piazza S.Marco; View of Canal grande by S.Lucia.*

ESSENTIAL BIBLIOGRAPHY

> Fiocco G., *La pittura veneziana del Seicento e Settecento*, Bologna, 1929;
> De Logu G., *I pittori minori veneti del Settecento*, Venice, 1930;
> Fiocco G., *Giovanni Richter*, in "L'Arte", 1932;
> Moschini V., *Il Canaletto*, Milan, 1954;
> Donzelli C., *I pittori veneti del Settecento*, Florence, 1957;
> Pallucchini R., *La pittura veneziana del Settecento*, Venice-Rome, 1960.

64

ROSSI PASQUALINO

Born at Vicenza in 1641, he began work as a painter in the Veneto but soon went to Rome which became his second home. He earned a reputation from the start, in 1668 being admitted among the "Virtuosi del Pantheon" and two years later membership of the "Accademia di S.Luca" was extended to him.

As well as his work at Rome, where he painted a number of altar-pieces (Aracoeli church, S.Carlo al Corso, S.Maria del Popolo), he had a long record of activity in the Marches where quite a number of altar-pieces by him may still be found from Fabriano and Matelica to Serra S.Quirico. The birth and upbringing of Pasqualino Rossi belong to the Veneto but his name is associated with Roman culture characterised by a clear style of painting, the colour material extremely fluid to the point of being almost without body and the effect "high-spirited" (Lanzi). It is, in addition, probable that in the Marches he would have been influenced by the works of Gentileschi and Guercino, located there.

Rossi is of particular note for his little genre paintings, which are as light-hearted as they are agreeable in choice of subject and of a manner distinctly modern and original.

PRINCIPAL WORKS

Dresden, Gemäldegalerie, *Adoration of the shepherds; S.John baptist preaching;*
Fabriano (Ancona), *S.Benedict, Madonna and child; S.Joseph and saints; S.Martyr* (1679); *S.Joseph* (1679); *Virgin and child with saints; Baptism of S.Austin; S.Mary of Egypt; S.John baptist; Angels ministering to S.Romualdo* (1674); *Dead S.Romualdo* (1674);
Matelica, Piersanti museum (Cathedral), *Mass of S.Gregory;*
Rome, S.Carlo al Corso, *Agony in the garden;*
S.Maria del Popolo, *Baptism of Christ;*
Pallavicini gallery, *The school mistress;*
Serrasanquirico, S.Lucia, *S.Lucy almsgiving; Angel appearing to S.Lucy; S.Lucy tortured; S.Lucy before the consul; Glory of S.Lucy.*

ESSENTIAL BIBLIOGRAPHY

P. A. Orlandi–P. Guarienti, *Abecedario pittorico*, Venice, 1753;
Lanzi L., *Storia pittorica della Italia*, Bassano, 1789 (ed. of Milan, 1823, II & III);
Bartoli F., *Le pittura, sculture ed architetture di Rovigo*, Venice, 1793;
Ticozzi S., *Dizionario degli architetti, scultori, pittori . . .*, Milan, 1830-3, III;
Serra L., *Elenco delle opere d'arte mobili nelle Marche*, Pesaro, 1925; *Inventario degli oggetti d'Italia: Provincia di Ancona ed Ascoli Piceno*, Rome, 1936;
Fiocco G., *Primizie di Pasqualino Rossi*, in "Arte Veneta", 1958;
Donzelli C.–Pilo G. M., *I pittori del Seicento veneto*, Florence, 1967;
Zampetti P., *La pittura del Seicento a Venezia* (Exhibition catalogue), Venice, 1959.

RUSCHI FRANCESCO

Born at Rome in about 1610 he was a noted engraver as well as a painter. According to Temanza, he studied under the chevalier d'Arpino. At a date not established, he moved to Venice and remained there on a permanent basis. His activity took him to nearby towns as well, including

Vicenza, Treviso and Conegliano. Boschini was not enthusiastic about him but instead he became friends with Sebastiano Mazzoni who dedicated a sonnet to him fulsome in its admiration.

Ridolfi (1648) in the context of his first work, the two tondos in the Sala delle quattro porte in the Doge's palace, called him both distinguished and noteworthy. Modern scholars have re-valued his personality, namely Fiocco (1929) and Moschini (1933).

He was not unaware of the Caravaggio departure but appreciative of Venetian art of the sixteenth century, especially that of Veronese. Ruschi is to be credited with having given Venice a new lease of artistic sensitivity (of neo-sixteenth century derivation) and this was an important feature in the resurgence of local art. At Rome, he may have been subject to Pietro da Cortona's influence. His Venetian altar-pieces imply a classical proclivity that is new and in open contrast to the naturalist leanings then dominating the Venetian scene under the lead given by Langetti, Zanchi and so on. Arslan noted traces of indebtedness to him in work of Carpioni and regarded Pietro Negri and Giovanni Antonio Fumiani as products attributable to his school.

The altar-piece depicting the *Madonna in glory with saints* now in S.Pietro di Castello church at Venice fully realises Ruschi's artistic intentions and the breadth of this achievement is most significant. He comes across unclouded by any hint of chiaroscuro naturalist teaching and well on the way to that luminous outlook culminating with Tiepolo.

The Virgin is represented: hieratic, regal and so much the focus of attention to upturned eyes that religious painting is by this work given a new direction in the sense of lyrical exaltation. This Venetian painting of the seventeenth century found acceptable and was repeated with widespread ramifications.

Ruschi died at Venice in 1661.

PRINCIPAL WORKS

Treviso, Civic museum, *Hagar sent away;*
Venice, Ospedaletto church, *Madonna and saints;*
 S.Pietro di Castello, *Madonna in glory with saints;*
 S.Teresa, *S.Ursula, Madonna and angels;*
S.Clemente in Isola, *Madonna of Loreto and saints;*
 Querini Stampalia foundation, *Diana;*
Vicenza, Cathedral, *Moses and Aaron.*

ESSENTIAL BIBLIOGRAPHY

Ridolfi C., *Le maraviglie dell'arte*, Venice, 1648 (ed. Hadeln, Berlin, 1914-24);
Mazzoni S., *Il tempo perduto, scherzi sconcertanti*, Venice, 1661;
Boschini M., *Le minere della pittura*, Venice, 1664; *Le ricche minere della pittura veneziana*, Venice, 1674;
Zanetti A. M., *Della pittura veneziana*, Venice, 1771;
Lanzi L., *Storia pittorica della Italia*, Bassano, 1789;
Fiocco G., *La pittura veneziana del Seicento e Settecento*, Verona, 1929;
Moschini V., *Una S.Orsola di Francesco Ruschi*, in "Bollettino d'arte", 1932-3;
Arslan W., *Il concetto di luminismo della pittura venetabarocca;*
De Logu G., *Pittura veneziana dal XIV al XVIII secolo*, Bergamo, 1958;
Donzelli C.-Pilo G. M., *I pittori del Seicento veneto*, Florence, 1967 (with further bibliography).

SEGALA GIOVANNI

Born at Murano (Venice) in 1663, he lived and worked in Venice where he died in 1720. The guild register contains his name for the period 1688 to 1700. He was a pupil of Pietro Vecchia, well esteemed and highly regarded by his contemporaries and writers of the eighteenth century.

Zanetti (1771) in fact rated him above Bellucci while Lanzi equated him with the artist last-named, stating that the one and the other were lovers of "strong shadow". The truth of the matter is that Segala was broadening his manner in the sense of a luminous approach to colour and in this sense, was anticipating developments in the field in the following century.

It may have been on this account that Zanetti deemed him "one of the greatest geniuses in painting of his time . . . he was the author of a style new and original". Segala was undoubtedly an artist full of originality and instinctive responses. His approach to painting led him away from the academic conventions of the seventeenth century, contributing new understanding to the problem of light.

Perhaps his most significant work in this regard is the altar-piece depicting the death of S.Lorenzo Giustiniani, in the church of S.Pietro di Castello at Venice. The figure of Giovanni Segala has only been the focus of expert attention in the last few years, whereas throughout the nineteenth-century he was quite forgotten. Of note in this context, the passage in Longhi's "Viatico" of 1946. A depth study should also consider the question of his relationship if any to Luca Giordano.

PRINCIPAL WORKS

Brescia, S.Pietro in Oliveto, *Miracle of S.Teresa;*

Dossena (Bergamo), Parish church, *Death of S.Joseph;*

Rovigo, S.Antonio abate, *Circumcision;*

Venice, S.Canciano, *S.Canciano in glory;*
S.Martino, *Madonna and saints;*
S.Pantaleone, *Christ healing the blind man;*
S.Pietro di Castello, *Death of S.Lorenzo Giustiniani;*
Scuola di S.Teodoro, *Paradise and the Holy trinity;*
Ateneo veneto, *Christ driving out devils;*
Accademia gallery, *Christ before Caiaphas.*

ESSENTIAL BIBLIOGRAPHY

Martinelli D., *Il ritratto, ovvero le cose più notabili di Venezia*, Venice, 1705;

Zanetti A. M., *Descrizione di tutte le pubbliche pitture . . .* Venice, 1733;

Orlandi P. A.–Guarienti P., *Abecedario pittorico*, Venice, 1753;

Zanetti A. M., *Della pittura veneziana*, Venice, 1771;

Lanzi L., *Storia pittorica della Italia*, Bassano, 1789;

Arslan W., *Studi sulla pittura del primo Settecento veneziano* in "Critica d'arte, 1935-6;

Longhi R., *Viatico per cinque secoli di pittura veneziana*, Florence, 1946;

Lorenzetti G., *Venezia ed il suo estuario* (ed. 1956, Rome);

Pallucchini R., *La pittura veneziana del Settecento*, Rome-Venice, 1960;

Ivanoff N., Giovanni Segala in "*Arte in Europa*—scritti di Storia dell'arte in onore di Edoardo Arslan", Milan, 1966;

Donzelli C.–Pilo G. M., *I pittori del Seicento veneto*, Florence, 1967.

STROIFFI ERMANNO

Born at Padua in 1616. Moschini listed his youthful journeys, which brought him into contact with pro-Caravaggio reformist circles to such an extent that he has been confused with Turchi and Carboncino (Fiocco, 1929).

In 1647 as a priest he founded the Oratorian house at Padua. Zanetti (1771) rightly regarded him as a follower of Bernardo Strozzi, adding moreover that "he imitated that good master's example at the start, thereafter moving away and striving after heightened effects of shade which led him on occasion to the valley of the shadow".

Stroiffi came closest to the Genoa painter in the altar-piece of the Ospedaletto church at Venice, of the *Virgin in glory with saints*. The artist adopted the manner of Strozzi, even his full-bodied brush-work is the same. The altar-piece for the Oratorian church at Padua, *The lament for Christ dead* brought him so near Strozzi that confusion has arisen. Later however, the artist found his own path, making intensive use of colour, his narrative manner being very spirited and colour-range festive as may be gauged from the *Miracles of S.Filippo Neri* in the monastry attached to the Chiesa della Fava, Venice.

In brief, Stroiffi imitated Strozzi, the development of the former's creative potential being largely due to the latter's influence. As has been well stated he is Strozzi's true counterpart even to the point of confusing ascriptions as evidenced by Boschini. Nevertheless, the work of Stroiffi lacks the creative force that is typical of the Genoa artist.

PRINCIPAL WORKS

 Padua, Chiesa dei Filippini, *Lament for Christ dead;*
 Venice, Ospedaletto church, *Madonna in glory with saints;*
 Ateneo veneto, *David and Isaiah;*
 Convento della Fava, *S.Filippo Neri series.*

ESSENTIAL BIBLIOGRAPHY

 Boschini M., *La carta del navegar pitoresco*, Venice, 1660;

 Zanetti A. M., *Della pittura veneziana*, Venice, 1771;

 Lanzi A., *Storia pittorica della Italia*, Bassano, 1789;

 Moschini G. A., *Guida per la città di Venezia*, Venice, 1815; *Guida per la città di Padova*, Venice, 1817;

 Fiocco G., *La pittura veneziana del Seicento e Settecento*, Verona, 1929;

 De Logu G., *Pittura veneziana dal XIV al XVIII secolo*, Bergamo, 1958;

 Donzelli C.–Pilo G. M., *I pittori del Seicento veneto*, Florence, 1967 (with further bibliography).

TREVISANI ANGELO

Born perhaps at Venice (probably his family came originally from Treviso) his real surname was Barbier. The date of his birth is put at about 1669. As Ivanoff (1953) indicated, he first joined the school of Zanchi and thus belonged to the group of "tenebrosi" painters which was a feature of Venetian art towards the close of the seventeenth century.

His early manner inclines to the austere and explicit, as may be seen from works at the Casa del Pellegrino near Lendinara. Later, he worked at Cavazzano in addition, and in 1709 dated an

altar-piece there which depicts five saints. According to Arslan, the large painting in the apse of S.Stae church at Venice would be of 1721; the artist shewed *S.Simeon* to whom was presented the baby Jesus.

His start under Zanchi enabled Trevisani to absorb the teachings of Piazzetta, whose influence is undoubted in early work though echoes are also present out of Celesti and Balestra. Pallucchini remarked on chromatic inter-play in line of descent from Pittoni, in the S.Stae altar-piece: "It might be termed an interpretation of the painter's enervated mode in a chiaroscural key" (Pallucchini, 1960).

Trevisani was responsible moreover for the *Visitation* in S.Zaccaria church again at Venice, where the debt to Piazzetta's manner is more evident. Later, the artist was further influenced by Tiepolo. In the *Agony in the garden* of S.Alvise church, the chromatic approach clearly stems from Tiepolo.

The gamut of experience through which Trevisani passed in the course of his career (he died some time between 1753 and 1755) did not prevent his output being distinguishable as in a manner that was his own. No kinship between Angelo and Francesco Trevisani, an artist of Veneto origin but associated with the school of Rome.

PRINCIPAL WORKS

> Brescia, S.Pietro in Oliveto, *S.Teresa in ecstasy;*
> Chioggia, Duomo, *S.Roch and the angel;*
> Lendinara, Basilica mariana, *A girl saved from the waters;*
> Madrid, Prado museum, *Madonna and child;*
> Padua, Capuchin church, *SS.Anthony abbot and Paul the hermit;*
> Rovigo, Concordi academy, *Caritas;*
> Venice, Accademia gallery, *Cleansing of the temple;*
> > Scuola della carità, *Assumption.*

ESSENTIAL BIBLIOGRAPHY

> Zanetti A. M., *Aggiunte al Boschini*, Venice, 1733;
> Orlandi P., *Abecedario pittorico*, Venice, 1753;
> Zanetti A. M., *Della pittura veneziana*, Venice, 1771;
> Brandolese P., *Pittura, sculture* etc., Padua, 1795; *Del genio de' lendinaresi per la pittura*, Padua, 1795;
> Arslan W., *Inventario delle opere d'arte di Padova*, Rome, 1936;
> Ivanoff N., *Angelo Trevisani*, in "Bollettino d'Arre", 1953;
> Donzelli C., *I Pittori veneti del settecento*, Florence, 1957;
> Pallucchini R., *La pittura veneziana del settecento*, Venice-Rome, 1960.

UBERTI PIETRO

Born at Venice in 1671, he was the son of Domenico—also a painter. Documentary evidence shews him at work in the city over the period 1715 to 1738, his name being entered on the guild register of Venetian painters.

His early portraits indicate a link with the art of Vittore Ghislandi. Subsequently, he was influenced by Piazzetta and, perhaps to a still greater extent, by Nazzari. But his reputation rests, in the main, on the prints made from his paintings.

Indeed, engravings give a line on his pictures, which must have been extremely numerous and well known. Later in life, he went to live in Germany where he appears to have died some time after 1762.

Among the works ascribed to this artist there are some expert attributions of recent date, based on print copies. Thus, Pignatti and the portrait of Giovanni Querini, procurator of S.Marco (1720); the work is on show at the Querini Stampalia gallery and had been regarded as generically of the Veneto school. A Zucchi engraving at the Correr museum in Venice is endorsed "Pietro Uberti pinxit" (Pietro Uberti painted it). Pitteri, Luciani and Zucchi were leading engravers of his portraits.

Uberti's figures are placed in a rather cold and conventional framework. In capturing his sitter's features, however, he was quite successful. The eight "Avogadori" (advocates) in the Doge's palace at Venice, painted 1730, illustrates the point.

Lorenzetti assigned the Gherardo Sagredo portrait to him, and Pignatti has added that of the procurator Giovanni Querini at the Querini Stampalia gallery in Venice as above.

His Swiss and German period produced the Salis-Seewis portrait (man and wife), dated 1762 and now at Bothmar castle in Coira.

In brief, Uberti was not among the progressives in art of the eighteenth century but remained associated with the style of portraiture of a Bombelli or Cassana.

BIBLIOGRAPHY

Zanotto F., *Storia della pittura veneziana*, Venice, 1837;

Paoletti E., *Il fiore di Venezia*, Venice, 1840;

Moschini G. A., *Guida per la città di Venezia*, Venice, 1815;

De Boni F., *Biografia degli artisti*, Venice, 1840;

Pignatti T., *I ritrattisti settecenteschi della Querini Stampalia*, in "Bollettino d'Arte", 1950;

Dazzi M., *Pietro Uberti, ritratti di G. & G. F. Querini*, in "Arte Veneta", 1953;

Ivanoff N., *I ritratti della Avogaria*, in "Arte Veneta", 1954;

Donzelli C., *I pittori veneti del settecento*, Florence, 1957;

Pignatti T., *Il museo Correr di Venezia, Dipinti del XVII e XVIII secolo*, Venice, 1960;

Pallucchini R., *La pittura veneziana del settecento*, Venice-Rome, 1960.

ZANCHI ANTONIO

Born in 1631 at Este within the territory of Padua, he learnt his first lessons in art there but soon set off for Venice where he became a front-rank painter.

His name is on the guild register of Venetian painters from 1687 to 1720. He lived at Venice all the while and died there in 1722. As a pupil of Matteo Ponzone, Zanchi was in touch with the tradition of Tintoretto represented by the Mannerists; it also came to him through the works of Palma the Younger. He seems to have been acquainted with Ruschi, whose decorative approach out of Paolo Veronese he absorbed, similarly a certain grandness of composition.

Later he was in touch with the young Luca Giordano, then associated with Neapolitan naturalist currents and also with Langetti of Genoa, another follower of Ribera. The upshot was that,

together with Loth, Zanchi became a leading exponent of the trend known as that of the "Tenebrosi", notable in Venetian art during the second half of the seventeenth century.

From his early work onwards, he showed individuality in interpreting the manner of the "tenebrosi". His colouring was intense and lively if not fluid, for it was subordinate to considerations of light and shade. Against that, he could use these factors to get drama out of his compositions rather like Tintoretto had done before him. Zanchi was enabled to make first-hand comparisons with Tintoretto. For he was commissioned to paint the great *Plague of Venice* in the Scuola di S.Rocco where Tintoretto had worked. Boschini relates how awed Zanchi was by the presence of Tintoretto's handiwork and begged pardon for his own. In the event, it turned out well and gave some idea of his powers to compose and interpret. The Kunsthistorisches museum at Vienna has the "bozzetto" for this painting; it is perhaps more telling than the finished work as proof of how great was his potential and how masterly his brush work in making light both dramatic and numinous. It is probable that his manner of painting had some effect, in turn, on the up-and-coming Giambattista Piazzetta. In process of time, from 1670 to 1690, Zanchi's experience widened and compositions lightened, due to the influence of Luca Giordano. But he remained loyal, as observed, to the "tenebrosi" who relied on dramatic contrasts of light and shade—with the proviso that time made him mellifluous, decoratively speaking. In this respect, his work was a source of stimulus to a good many artists at the turn of the eighteenth century.

PRINCIPAL WORKS

Asolo, Civic museum, *Il tempo;*
Bergamo, S.Maria Maggiore, *Moses striking water from the rock;*
Calaone (Padua), Parish church, *Adoration of the Magi;*
Capodistria, Duomo, *Wedding-feast at Cana;*
Este, Chiesa della salute, *Betrothal of the Virgin;*
Lovadina (Treviso), Parish church, *Communion of saints;*
Padua, S.Giustina, *Martyrdom of S.Daniel;*
Rovigo, Madonna del soccorso, *Allegory of Pietro Loredan;*
Treviso, S.Nicolò, *Virgin and S.Albertus Magnus;*
Venice, S.Maria del Giglio, *Abraham dividing up the world;*
 S.Zaccaria, *Procession of "corpi santi";*
 Scuola di S.Rocco, *Plague of Venice;*
 Seminario patriarcale, *Burning of heretical books;*
Vienna, Kunsthistorisches museum, *Plague of Venice* (bozzetto).

ESSENTIAL BIBLIOGRAPHY

Mazzoni S., *Il tempo perduto, scherzi sconcertanti* Venice, 1661;
Boschini M., *Le minere della pittura,* Venice, 1664; *Le ricche minere della pittura veneziana,* Venice, 1674;
Mariette P. J., *Abecedario . . .,* 1771 in "Archives de l'art français" (1859–60);
Zanetti A. M., *Della pittura veneziana,* Venice, 1771;
Moschini G. A., *Guida per la città di Venezia,* Venice, 1815;
Riccoboni A., *Antonio Zanchi, pittore veneto, nel secondo centenario della morte,* in "Rassegna d'Arte", 1922;
Fiocco G., *Giambattista Langetti e il naturalismo a Venezia,* in "Dedalo", 1922–3; *La pittura veneziana del seicento e del settecento,* Verona, 1929;

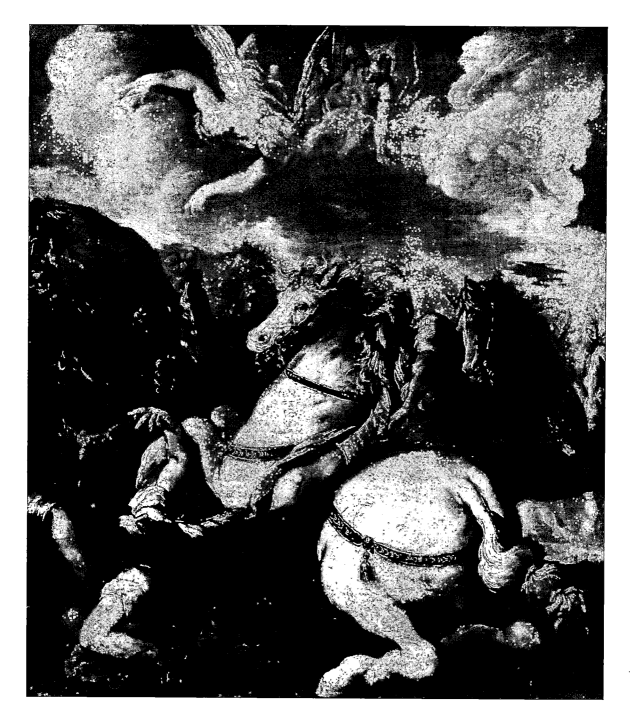

FRANCESCO MAFFEI
St. Paola falls from his Horse
Civic Museum, Pesaro

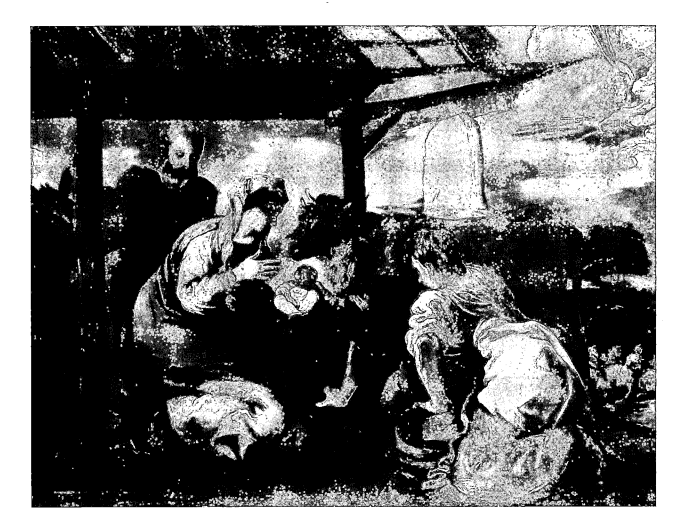

FRANCESCO MAFFEI
Adoration of the Shepherds
Ashmolean Museum, Oxford

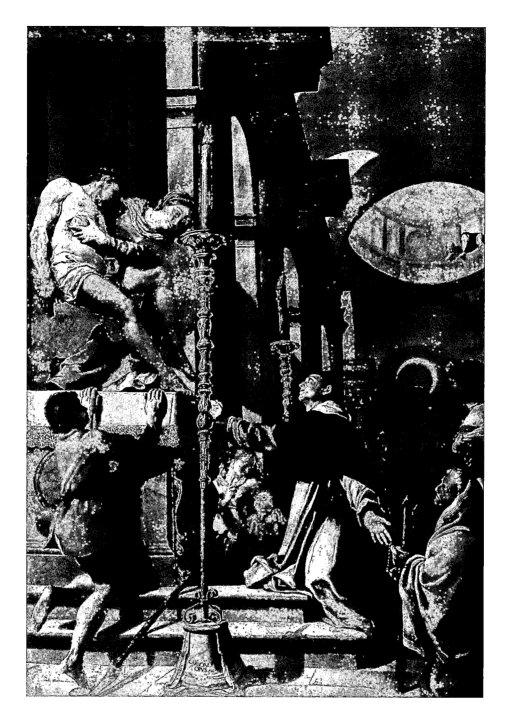

GIOVANNI CARBONCINO
The miracle of St. Susone
Church of St. Nicolo, Treviso

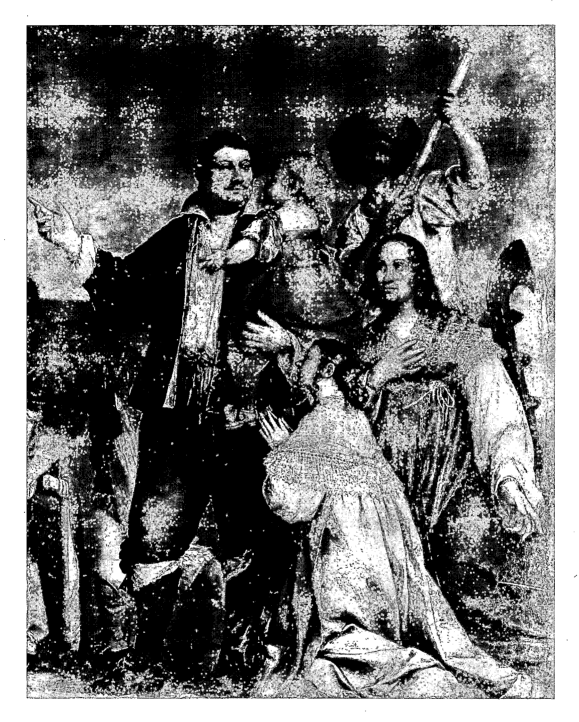

GEROLAMO FORABOSCO
Rescue Scene (part)
Parish Church, Malamocco

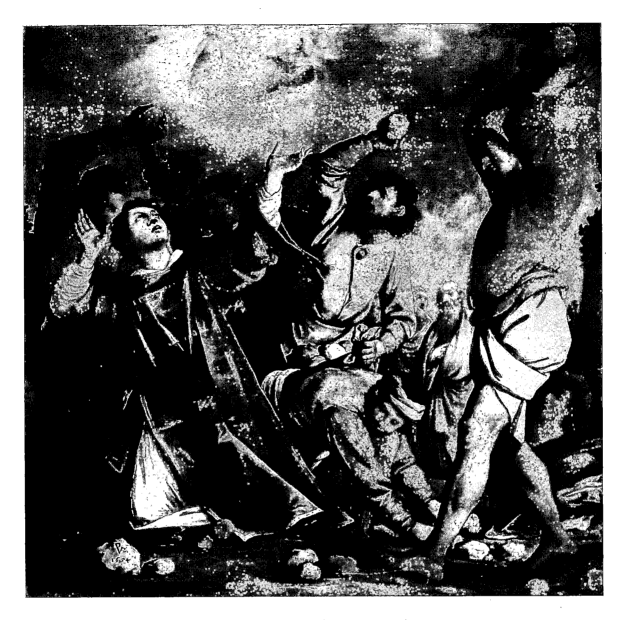

PIETRO MUTTONI (DELLA VECHIA)
The Martyrdom of St. Stephen
Civic Museum, Treviso

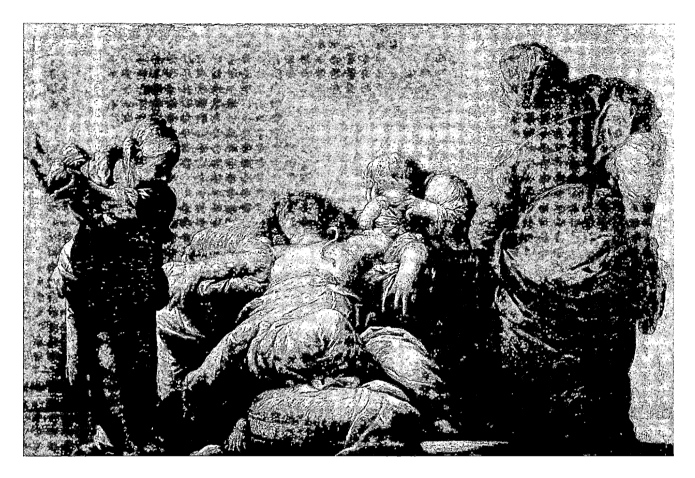

SEBASTIANO MAZZONI
The death of Cleopatra
Accademia dei Concordi, Rovigo

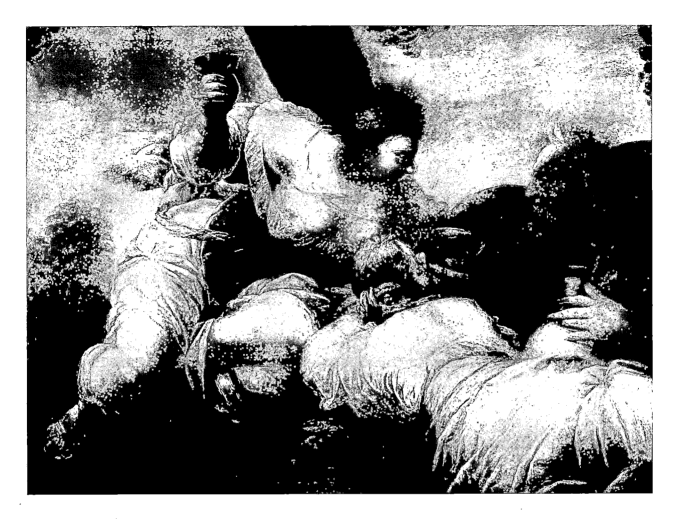

SEBASTIANO MAZZONI
Lot's daughters
Accademia dei Concordi, Rovigo

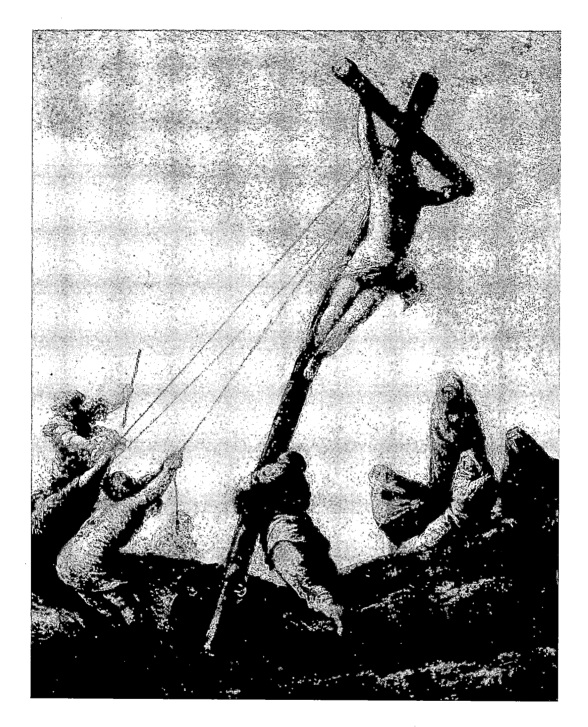

SEBASTIANO MAZZONI
The erection of the Cross
Ubicazione Ignota, Venice

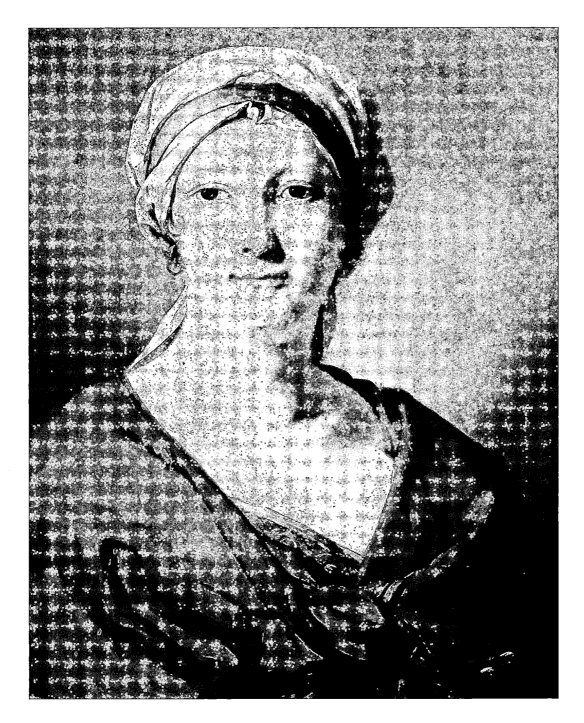

GIULIO CARPIONI
Portait of a Woman
State Museum, Berlin-Dahlem

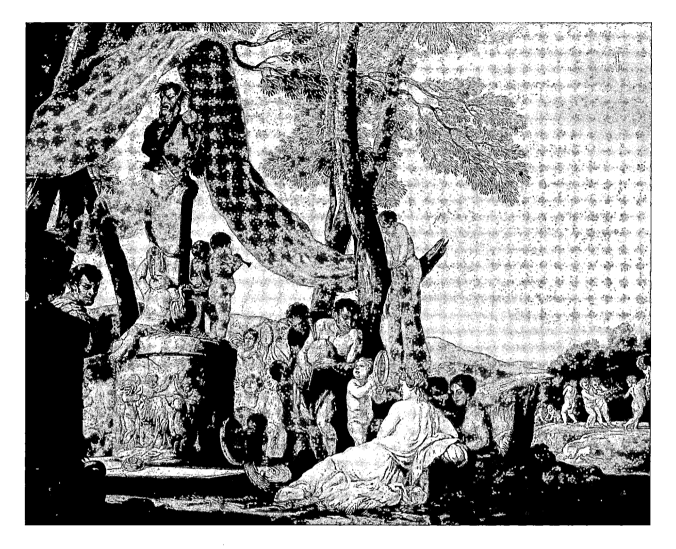

GIULIO CARPIONI
Baccanale
Columbia Museum of Art, U.S.A. (Kress Collection)

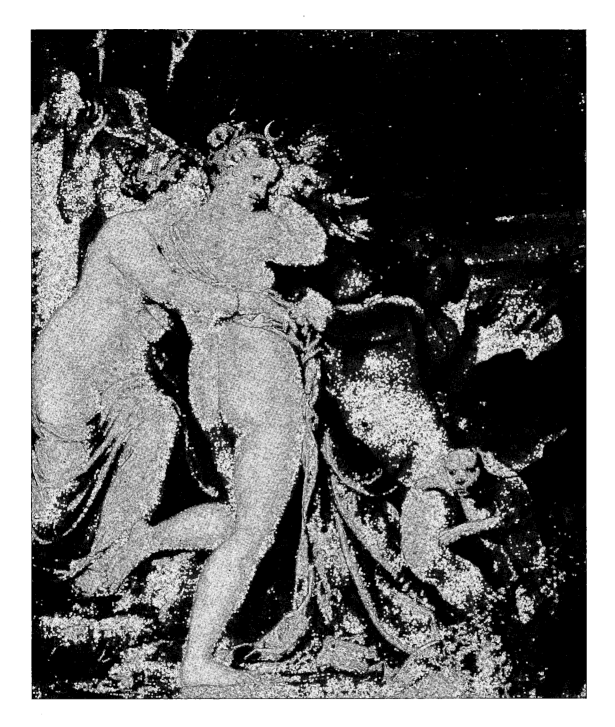

PIETRO LIBERI
Diana & Acteon
State Museum, Berlin

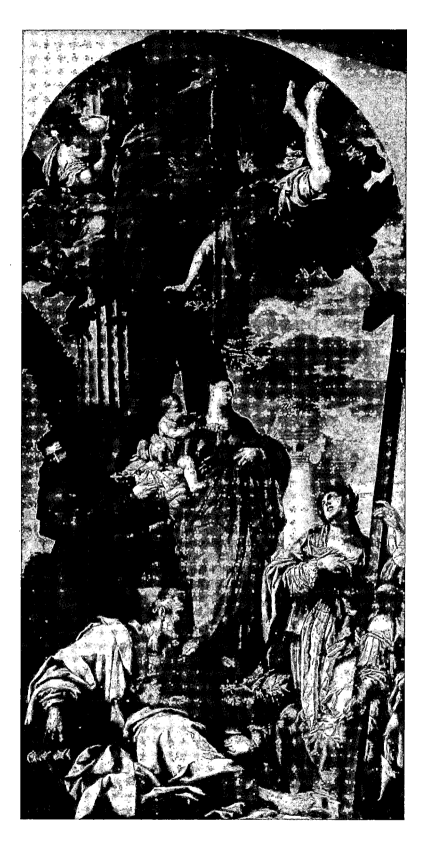

FRANCESCO RUSCHI
Madonna in Glory with Saints
Church of St. Peter di Castello, Venice

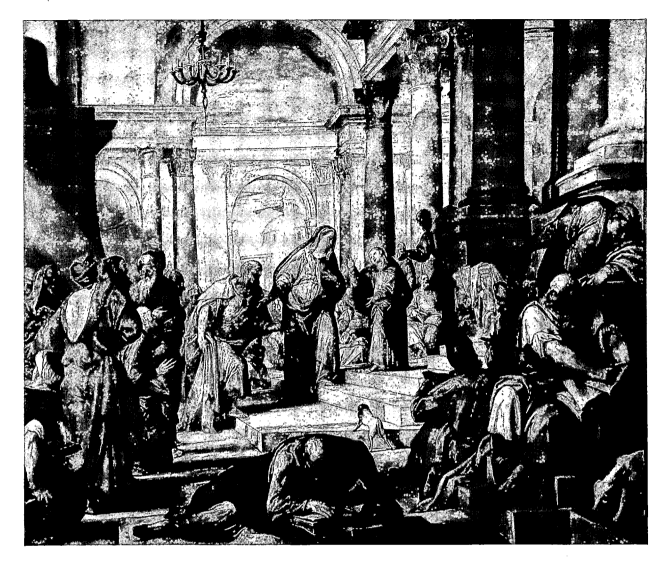

GIANANTONIO FUMIANI
Christ and the Doctors
Collection Leonardo La Piccirella, Florence

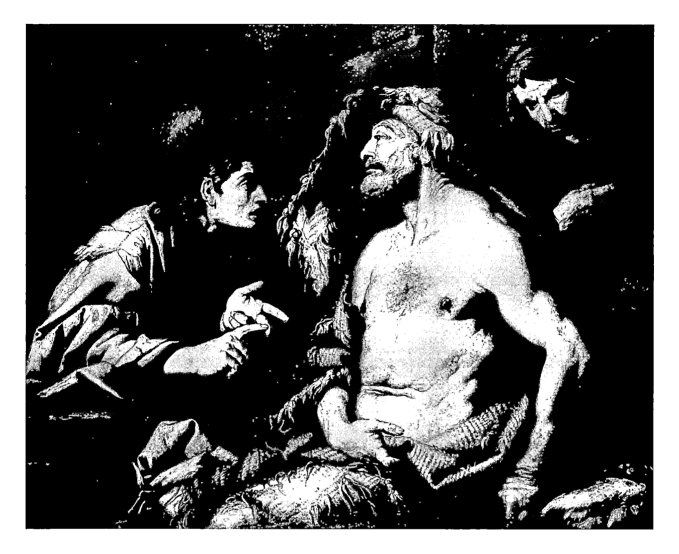

GIAMBATTISTA LANGETTI
The Philosopher Diogenes
National Museum, Varsova

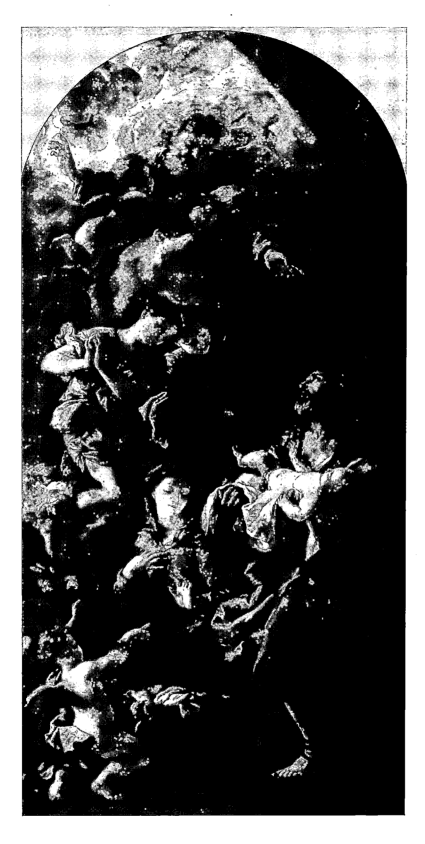

KARL JOHANN LOTH
The Sacred Family with adoring Angels
Church of S.Silvestro, Venice

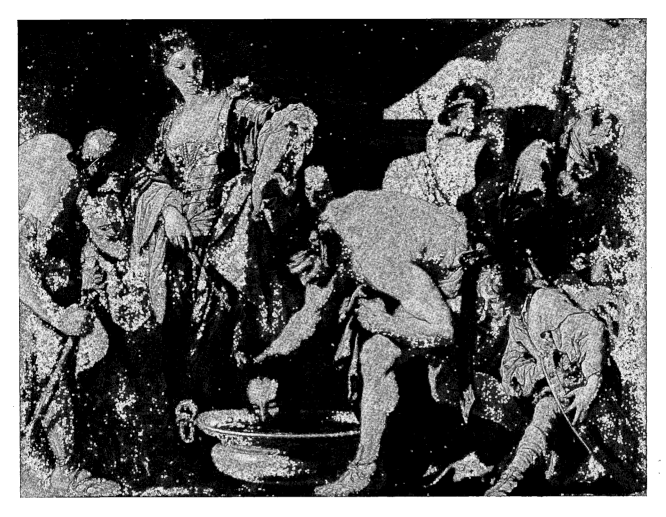

ANTONIO ZANCHI
Herodias
Palazza Widmann-Foscari, Venice

ANTONIO ZANCHI
The Plague of Venice
Kunsthistorisches Museum, Vienna

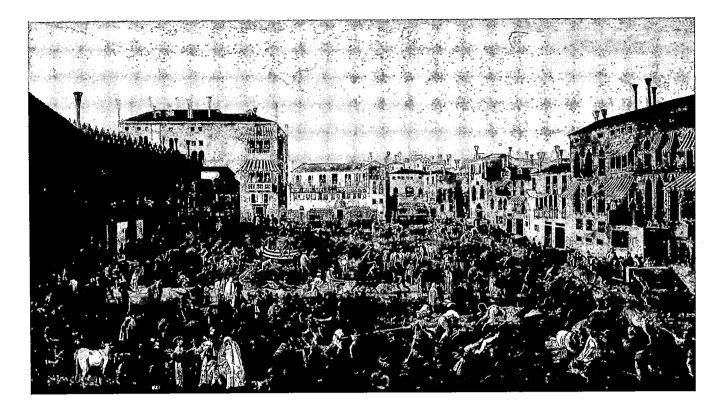

JOSEPH HEINZ
Bull-baiting in Campo S.Polo
Correr Museum, Venice

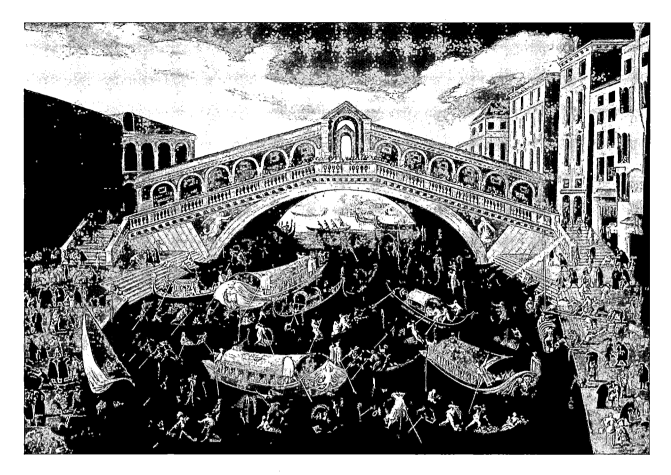

JOSEPH HEINZ
Cortege at Rialto Bridge
Estense Gallery, Modena

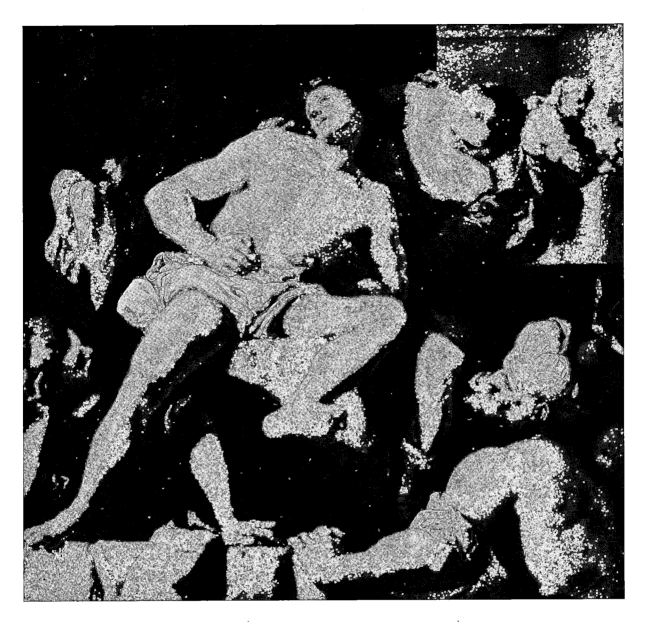

ANTONIO CARNEO
The proof of poison
Castello dei Conto Velentinis

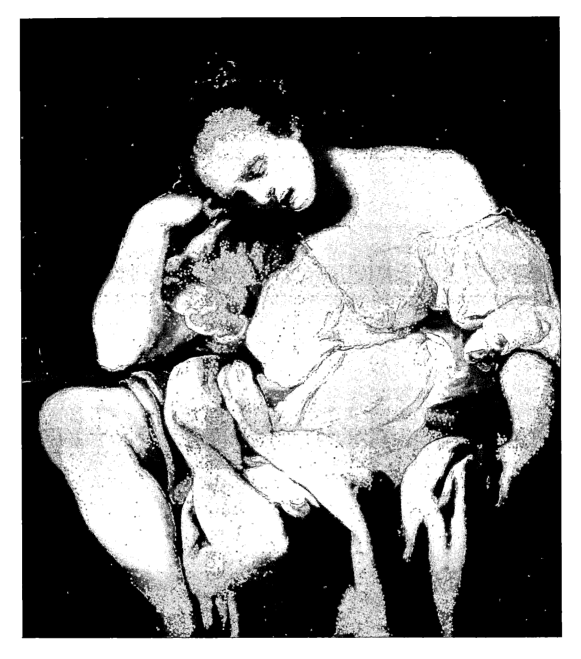

ANTONIO CARNEO
Dido deserted
Gemona (Udine), Mazzanti collection

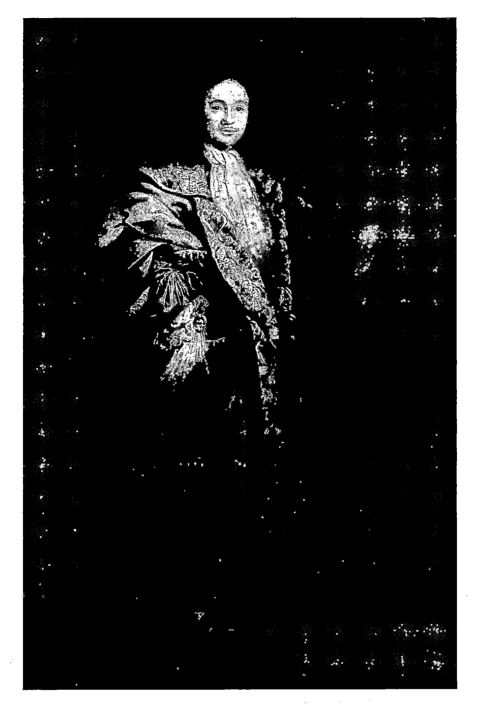

SEBASTIANO BOMBELLI
Portrait of Paolo Querini
Querini Stampala Gallery, Venice

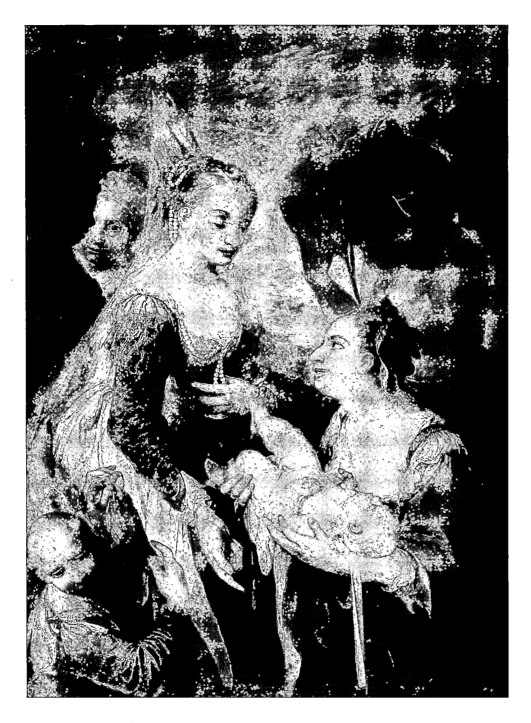

ANDREA CELESTI
The finding of Moses
Regio Emilia, Parmeggiani Civic Gallery

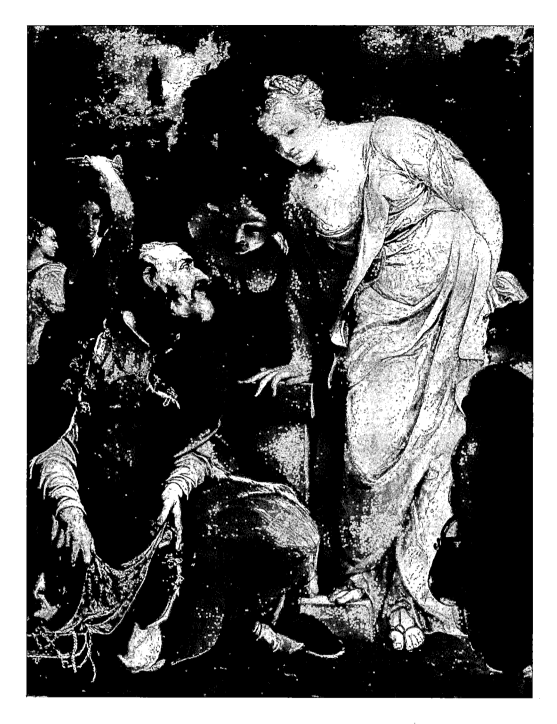

ANTONIO BELLUCCI
Rebecca at the Well
Pommersfelden, Dr.Karl Graf von Schonborn collection

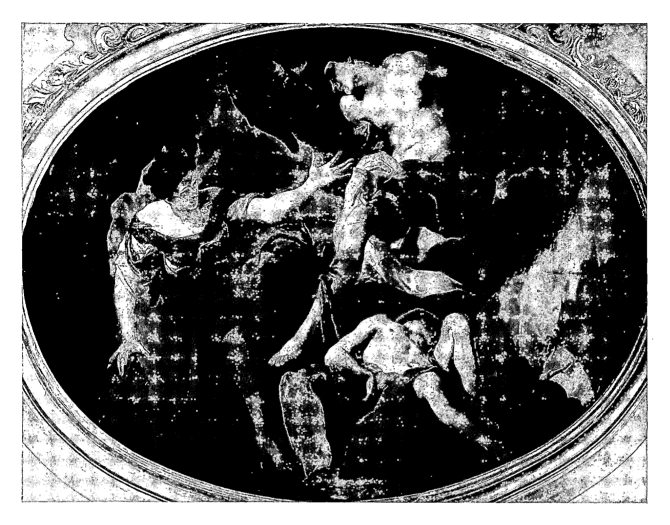

PAOLO PAGANI
Hagar in the Wilderness
Palazzo Salvioni, Venice

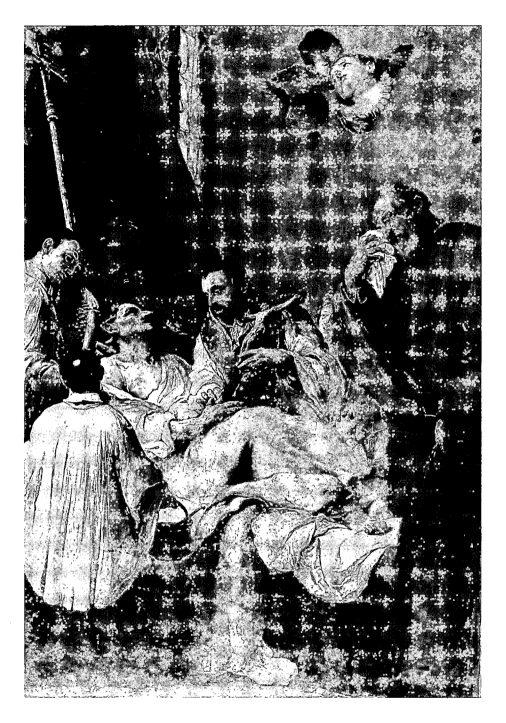

GIOVANNI SEGALA
Death of S.Lorenzo Giustiniani
S.Pietro die Castello, Venice

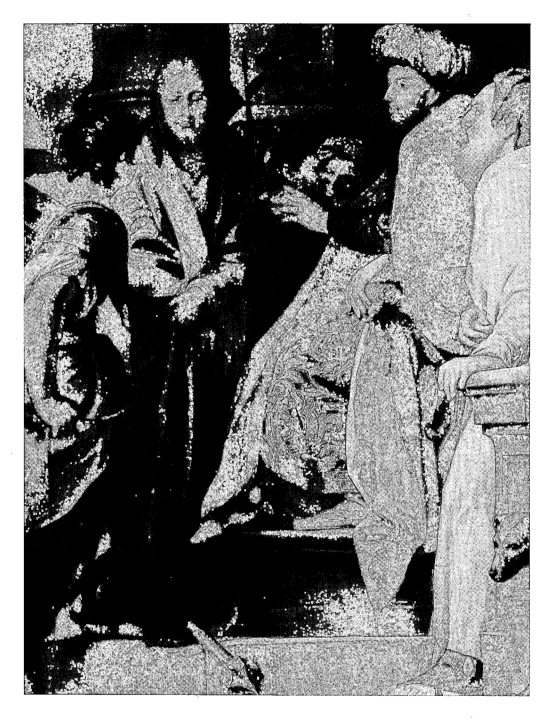

ANTONIO MOLINARI
Christ before Caiaphas
Accademia Gallery, Venice

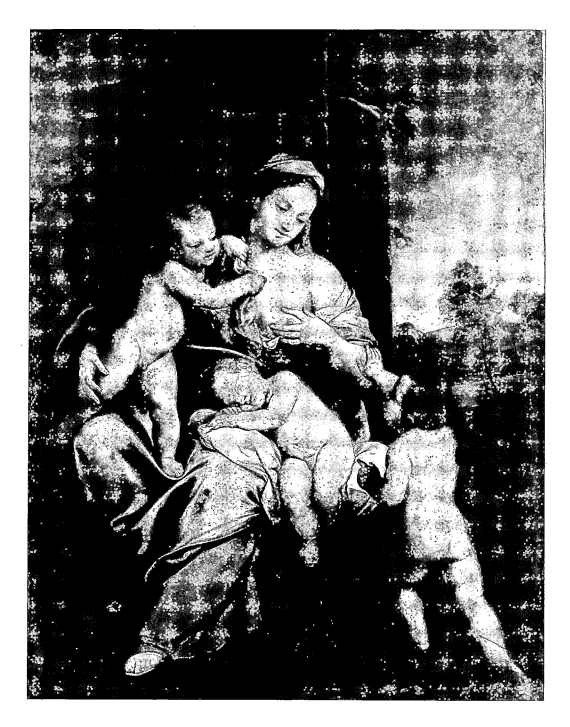

GREGORIO LAZZARINI
Charity
Kereszteny Museum, Esztergom

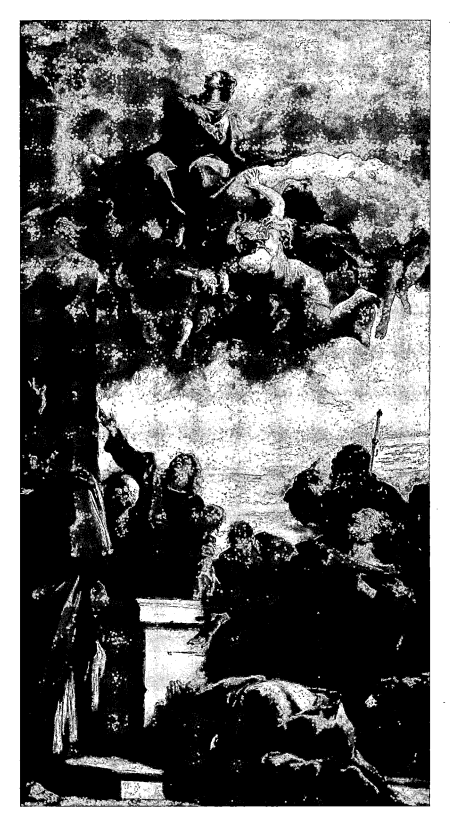

SEBASTIANO RIĊCI
Ascension of the Virgin
Museum of Fine Arts, Springfield, Mass.,U.S.A.

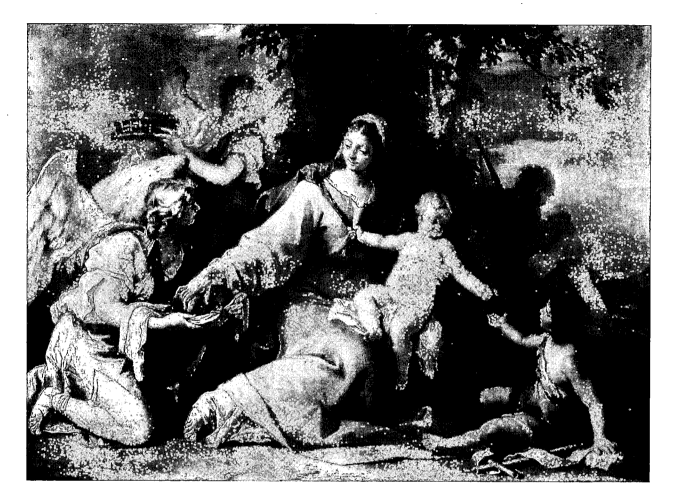

SEBASTIANO RICCI
Rest on the flight into Egypt
E. Lutomirski collection, Milan

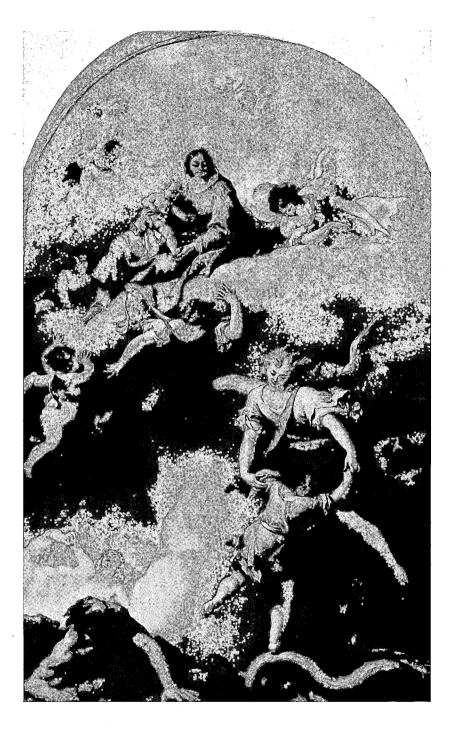

SEBASTIANO RICCI
Madonna in Glory and Guardian Angel saving a Child
Evangelico Luterana Church, Venice

SEBASTIANO RICCI
Christ in the Garden of Olives
Kunsthistorisches Museum, Vienna